IMAGES
*of America*

# SUNNYSLOPE

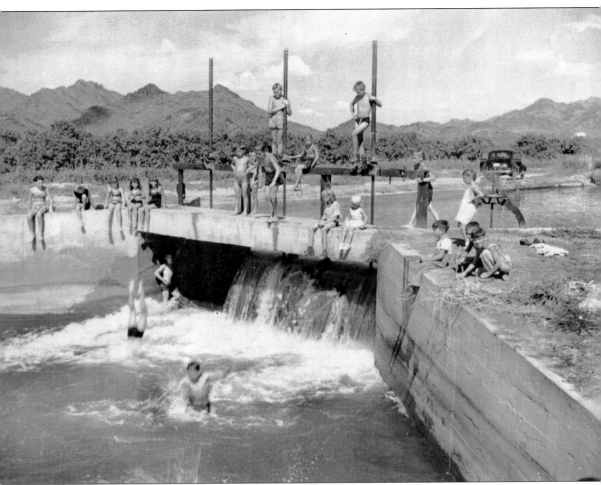

In this 1940s photograph, children play in the Arizona Canal off Seventh Street. Surfboarding on the canal was another thing that children did—a board, a rope, and a car were needed for this activity. (Courtesy of the Sunnyslope Historical Society.)

**ON THE COVER:** Desert Mission's multiuse Dodge van was utilized for fun trips to parks, libraries, special events, and camp sites in the White Mountains of eastern Arizona. What lifetime memories these outings created for the youngsters. This photograph was probably taken in the early 1940s. (Courtesy of the Sunnyslope Historical Society.)

# IMAGES
# *of America*
# SUNNYSLOPE

Reba Wells Grandrud

ARCADIA
PUBLISHING

Published by Arcadia Publishing
Charleston, South Carolina

Printed in the United States of America

Library of Congress Control Number: 2013941119

For all general information, please contact Arcadia Publishing:
Telephone 843-853-2070
Fax 843-853-0044
E-mail sales@arcadiapublishing.com
For customer service and orders:
Toll-Free 1-888-313-2665

Visit us on the Internet at www.arcadiapublishing.com

*Dedicated to DJW in fulfillment of a dream
and to NFG in making the reality possible*

# CONTENTS

# ACKNOWLEDGMENTS

This book reflects an attempt to tell the history of Sunnyslope, primarily from the photograph collection preserved by the Sunnyslope Historical Society (SHS) in its museum. All images herein are provided courtesy of the SHS unless otherwise noted. It is impossible to list all the individuals who have given originals or copies of family photographs and other memorabilia since the historical society began in the late 1980s, but the contributions of all are appreciated, whether large or small, especially the following: the archives of the John C. Lincoln North Mountain Hospital; *Sage* newspapers for bound volumes and boxes of individual photographs from the Lillian Stough collection; Edna Phelps for writings and family photographs; Edna McEwen Ellis for writings and family photographs; the autobiography of Charley H. Abels, *The Last of the Fighting Four*, published in 1968; the City of Phoenix Fire Department; and Bryan Memorial Extended Care Center Scrapbooks, 1992–1999.

Frank and Waunita Melluzzo and members of the Melluzzo family donated the property that is now called the Kreamer Campus at 737 East Hatcher Road.

Through the efforts of Ron Gawlitta, A&C Development Company donated the two historic buildings that make up the Sunnyslope Historical Society Museum: the 1953 People's Drug Store and the Lovinggood-Inskeep 1945 House.

Jim Kreamer, Otis DeHart, and Hal Hall led the rehabilitation effort that turned the aging drugstore building into an attractive, useful museum with space for exhibits, collection storage, a volunteer office, and public meetings.

Lela L. Armijo (1906–2003) remembered the Sunnyslope Historical Society with a generous bequest in her will.

Connie Kreamer, founding president of the Sunnyslope Historical Society, had the vision and the dedication to start the systematic collection of Sunnyslope's history in the late 1980s, ably assisted by her husband, Jim Kreamer. The Kreamers' devotion to this work continues strong in 2013.

# FOREWORD

From desert to thriving community, historian Reba Wells Grandrud, with the assistance of society founder Connie Kreamer, has captured the event-filled time line of the historic Sunnyslope community.

Shortly after the turn of the 20th century, miners, intrepid immigrants, characters (some honorable, others not), and health seekers came to this hostile desert environment to discover a better way to live.

Like many people from around the world suffering from lung problems, my mother, Janice Fay Hansen, needed a completely dry environment just to breathe. Told to come to the sunny slopes of Arizona by her Nebraskan doctors, she arrived in time to save her life and, with my father Chester L. Hansen, help shape the diverse and energetic Sunnyslope community.

Growing up in Sunnyslope was not always about heat, scorpions, and flash floods. My best memories are vibrant sunsets, sleeping under the stars, a town where everyone knew one another, and all had an opportunity to build a dream life. My family, now in its fourth generation, continues to work and live in and around Sunnyslope. Each new generation of Hansens knows of our beginnings at the base of S Mountain, in an area all of Phoenix recognizes as Sunnyslope.

The Sunnyslope Historical Society Museum is housed in an original and now restored drugstore building—People's Drugs was the first pharmacy in Arizona with a drive-through window. Society members have accumulated, documented, and preserved thousands of pieces of early Sunnyslope memorabilia, including a cottage home and furniture indicative of early life in the community. The museum presents a collection of history for everyone to visit and learn about this great desert community.

Read and view the photographs through this book and experience what it was like to live in the desert before American life became so mobile. See for yourself how early desert dwellers conquered the environment to form a community that continues to thrive, recalling a past filled with memorable characters.

—Craig Hansen

# INTRODUCTION

Sunnyslope is unique. It is a place where people came to die but lived on to leave their mark on society or produce offspring who did.

Now, in the opening decades of the 21st century, Sunnyslope remembers its past. In burgeoning, rapidly changing neighborhoods, residents believe deep down that they still live in a small town where everyone knows everyone else, and nothing is more fun than getting together and talking about a 'Sloper past.

In reality, the beauty of the area and the memories are about all that is unchanged. Sunlit hills, the "sunny slopes" that inspired the community's name more than 100 years ago, are now covered with expensive homes. Sunnyslope today is just one of several other communities that make up the North Mountain Village Planning Committee of Metropolitan Phoenix, the capital city of Arizona and sixth most populous city in the United States.

Community and city were, and are, located in the low elevation of the Salt River Valley, a vast alluvial plain that stretches hot and dry from the Superstition Mountains to the Estrella Mountains of central Arizona. The desert climate is tempered by several rain- and snow-fed rivers—the Verde, the Salt, the Gila, the Agua Fria, and the Hassayampa—that come together here. Historian Tom Sheridan called the Salt River Valley and these rivers "the greatest conjunction of arable land and flowing water in the Southwest." Here, from AD 650 to 1450, prehistoric Hohokam people constructed one of the largest, most sophisticated preindustrial irrigation networks known, then abandoned the area prior to the arrival of Spanish explorers in 1540.

William R. Norton, a California architect who loved the desert, is considered to be the founder of Sunnyslope. Norton acquired many acres of land north of the Arizona Canal and is the person responsible for naming the area. According to the story, one day, he and his daughter were riding over the desert in their buggy. Young Alice saw the sun shining on the slopes of North Mountain and commented "Isn't that a beautiful sunny slope?" Norton like the sound of the name and used it when he platted the first subdivision, Sunny Slope, in 1911. (The name remained two words until the mid-1940s.) The subdivision's boundaries were from Third Street west to Central Avenue and from Dunlap Avenue south to Alice Avenue.

The first permanent settlers, like Edna Phelps's family, were willing to brave the harsh summers in order to enjoy the desert the rest of the year. They homesteaded or purchased land in the Sunnyslope area. Many early families had members who were suffering from tuberculosis, asthma, and other respiratory problems; they trekked to the desert outside of Phoenix to take advantage of the always hot, dry air north of the Arizona Canal.

Today, Sunnyslope boundaries are considered to be from Nineteenth Avenue on the west to the mountains on the east at Nineteenth Street and from Thunderbird/Cactus Road on the north to Northern Avenue on the south. Early boundaries of Sunnyslope were roughly Seventh Avenue to Twelfth Street and from the Arizona Canal to the North Mountain Range.

The area known as Valley Heights was from Seventh Avenue west to Nineteenth Avenue and from Peoria Avenue to the Arizona Canal. Desert Cove was north of Peoria Avenue to Shaw Butte Mountain and from Seventh Avenue to Nineteenth Avenue. (North–south roads west of Central Avenue are called avenues, and east of Central Avenue, they are called streets.)

# One

# THE ARIZONA CANAL

Home to prehistoric indigenous people who practiced subsistence agriculture, the greater Salt River Valley remained uninhabited on a permanent basis until after the American Civil War. Situated in the Sonoran Desert section of the Basin and Range Physiographic Province, the broad, level valley is cut up by small ranges of fault block mountains. The Salt River is the chief tributary of the Gila River and joins that stream near the Estrella Mountains west of Phoenix.

In 1867, while cutting river grasses for Fort McDowell military post, John W. "Jack" Swilling recognized the irrigation potential of the long-abandoned Hohokam ditches and organized the first of many irrigation and canal companies. Ancient waterways were made usable by simply cleaning them out, water flowed, and agriculture once more became a major industry in the Salt River Valley. By 1890, valley population was 11,000, and four waterways north of the Salt River—the Salt River Valley Canal, Maricopa Canal, Grand Canal, and Arizona Canal—were irrigating 50,000 acres, all south of the Arizona Canal.

The Arizona Canal was the most ambitious project of that period. It did not follow "Hohokam blueprints" but came off the Salt River 40 miles upstream and flowed along the northern edge of the Salt River Valley. The first 42-mile segment was constructed between 1883 and 1885 by William J. Murphy for the Arizona Canal Company, then extended west for an additional five miles.

The canal today follows essentially the original alignment. The portion of the Arizona Canal that runs through Sunnyslope is 2.81 miles and is under the administration and management of the Salt River Project.

Present-day Sunnyslope began north of the Arizona Canal. In the 1890s and into the first decade of the 20th century, the sparse population was transmigratory. Prospectors set up temporary camps as they looked for mineral wealth; wild horses and bands of sheep coming off sheep driveways crossed the desert looking for water, and sufferers from respiratory diseases came seeking improved health in the dry air and abundant sunshine. Tents and makeshift frame houses were the first homes.

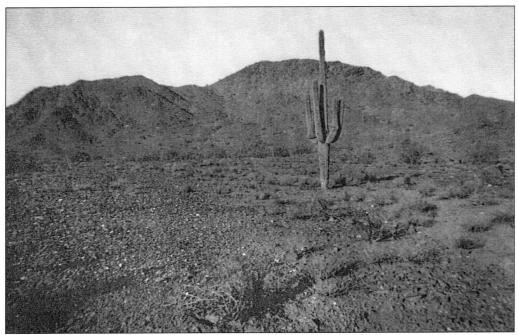

Seen here is the desert floor at the base of Shaw Butte, a distinctive mountain near Nineteenth Avenue and Thunderbird Road. Well known to prehistoric Indians, the mountain hosts a popular Phoenix Mountain Preserve hiking trail, along with a bevy of communication towers.

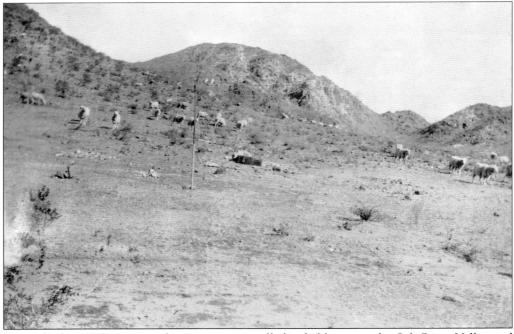

Since the late 19th century, sheep were seasonally herded between the Salt River Valley and summer pastures in the hill country to the north.

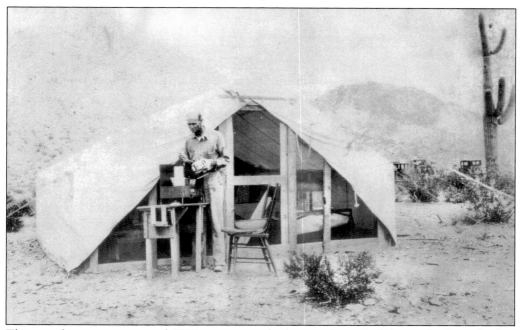

This tent house, seen around 1927, represents the home of a typical desert dweller, whether health seeker or prospector, who lived north of the Arizona Canal in the 1920s. Note the cars in the background.

Two communities, Desert Cove and Valley Heights, grew near Shaw Butte as health-seekers increasingly came to the desert there. Valley View Sanitarium opened in 1924 near Nineteenth Avenue and the west end of the mountain.

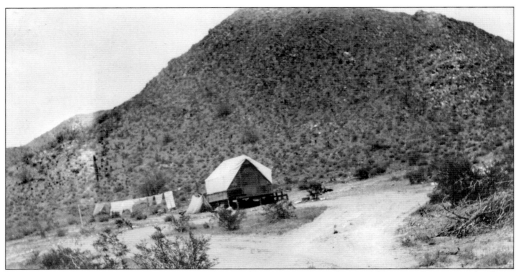

William Abbott, a tubercular sufferer, came alone in 1927 and set up his tent house at the base of a hill that is known today as S Mountain.

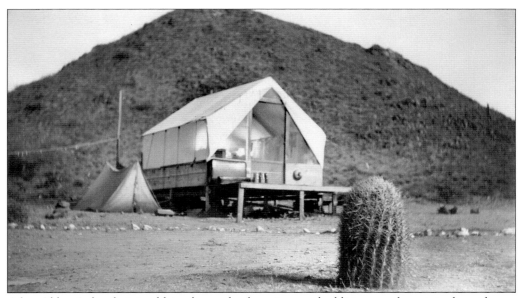

After Abbott's family joined him, he made alterations and additions to the original tent house by building up partial walls and adding frame windows with "screen and canvas to keep out the desert dust," according to him. Sheepherders crossed Abbott's land as flocks were brought to the Arizona Canal for water. Often, a lamb was given to the Abbotts for food or as a pet.

# Two

# EARLY SETTLERS

By 1900, the healthful climate of Arizona was well known. Wealthy sufferers could find care in resort-like sanatoriums, but tents were banned inside Phoenix city limits. Indigents had no choice except wagons or makeshift housing on the desert. Cheap, available land and the beauty of the desert were incentives for those, such as the Ernest Phelps family, who could afford to buy. Many early settlers helped shape the community, but only two such individuals are highlighted here.

In 1891, Californian William R. Norton hoped lingering poor health would dissipate in the dry air and sunshine of Phoenix, and he was right. Resuming his architectural practice, he began investing in large open tracts. As Norton's love of the desert deepened, he was often seen, year-round in business attire, walking from his home on Washington Street west of the new state capitol out to the desert.

Norton relocated his family in 1907 to the desert and a comfortable frame home to which he continuously added rooms. About the same time, he designed two of his most significant buildings—the 1907 Gila County Court House in Globe and the 1908 Carnegie Library in Phoenix. Then, in 1911, he made history with his first subdivision, Sunny Slope. Less than a decade later, he opened a second one, Norton Subdivision. William Norton died at age 85 in 1938 from injuries sustained in an auto-pedestrian accident. His descendants still live in the valley. The two fine public buildings are extant, and Sunnyslope, the community he put on the map, is increasingly a most desirable place to live.

Charles H. Abels first saw Arizona in 1916 as a 17-year-old Ohio lad who joined the border cavalry to "chase Pancho Villa around in Mexico," as he wrote in his autobiography. Then, in 1921, "a very sick and disillusioned young man," war veteran Abels and his bride, Elenora, settled between Sunnyslope and Hyatt's Camp. They opened the first gas station and store between Phoenix and Cave Creek and developed the first water utility company in their area. Campaigning with the slogan "He Wears No Man's Collar," Abels fought for local improvement issues. He was elected four times to the Arizona House of Representatives and was influential in the political arena between 1947 and 1954.

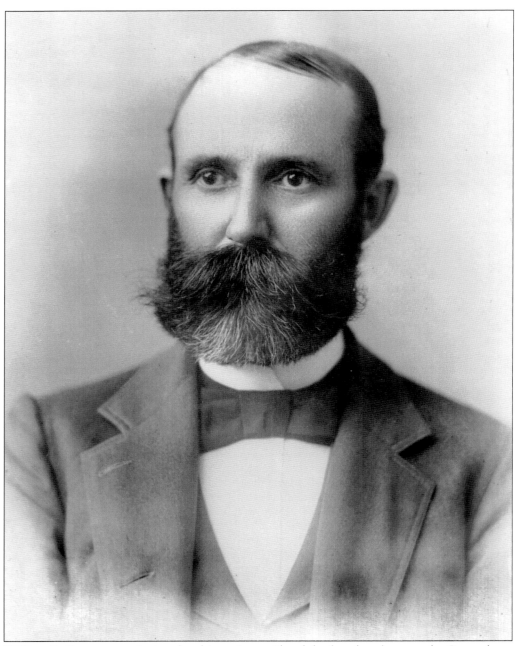

William R. Norton, a professional architect, is considered the founder of present-day Sunnyslope, Arizona, platting its first subdivision in 1911. He was born in 1853 in Massachusetts. In 1880, he went to San Francisco, where he met and married his wife, Mary Emma, and opened an architectural office. The lingering effects of black measles and pneumonia caused him to seek complete recovery in the healthful climate of central Arizona, and he brought his family to Phoenix in 1891. His 1895 home at 2222 West Washington Street is in poor condition but is under the watchful eye of the Capitol Mall Association, which would like to see it returned to its former grandeur.

Mary Emma Norton, William Norton's wife, was a graduate of New England Conservatory of Music. She taught piano in Phoenix in the early 20th century.

Pictured here is a plat of the 40-acre Sunny Slope subdivision. See this book's introduction for how the Sunny Slope name was coined.

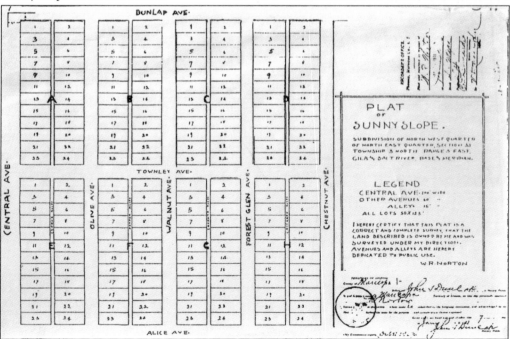

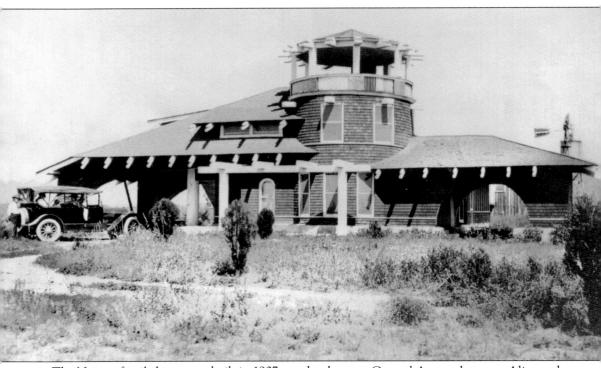

The Norton family home was built in 1907 on what became Central Avenue between Alice and Ruth Streets (named, respectively, for Norton's daughter and niece). Norton lived there until he died in 1938 as the result of a car-pedestrian accident.

Edna Phelps (January 28, 1905–May 5, 1995) was a respected local historian who helped preserve the history of the area. Phelps learned to love Sunnyslope and the desert. She taught English at Sunnyslope High School and was an active supporter of the Sunnyslope Historical Society after it was organized in 1989.

This is an early snapshot of Edna Phelps, the older daughter of J. Ernest and Wilmina Phelps. The Phelps family came from California around 1914 to a homestead on arid land north of the canal.

The Phelps homestead was just north of the Arizona Canal. Ernest Phelps had come to Arizona for free land, which he obtained when he applied in 1914 for a 160-acre desert homestead, one of the last available homestead parcels in the area. Phelps had to follow the guidelines and prove up on the land. He and his family built a house, outbuildings, and a water tank. Phelps tried to grow citrus trees but was unsuccessful, because canal water was not available.

Older members of the Phelps family are seen here relaxing on a summer day. The family home was at Twelfth Street and Northern Avenue, approximately the site of the present-day Arizona American Italian Club at 7509 North Twelfth Street. The Phelps children enjoyed having a horse there; they called her Dolly.

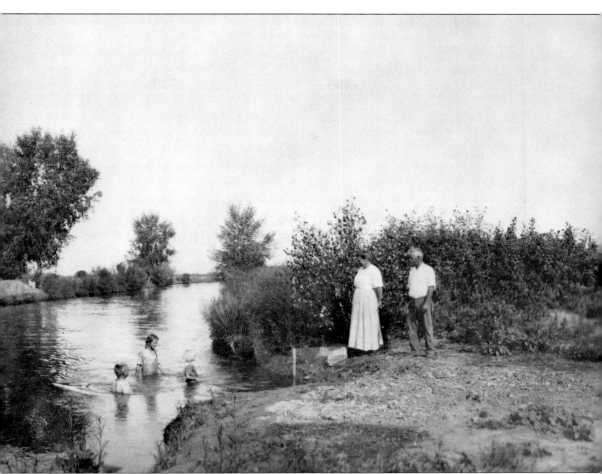

The above image was taken around 1915. The canal was a popular cooling-off spot, especially in the extreme heat of a central Arizona summer. Even small children were allowed to play in the water, kept safe by a tether-rope tied to a sturdy stake. The older children enjoyed swimming and surfboarding, usually near one of the five bridges that, over the years, crossed the Arizona Canal. Bridges were at Seventh Street, Central Avenue, Dunlap Avenue, Seventh Avenue, and Nineteenth Avenue. In 1929, Edna McEwen Ellis wrote that the Central Avenue span over the canal was "a narrow, wooden bridge with wooden A-frame sides. The canal [ran] to the northwest so the bridge pointed to the northeast, not north as Center Street was. So a car had to zig to the west across the bridge and zag back to the east to get back onto the street alignment."

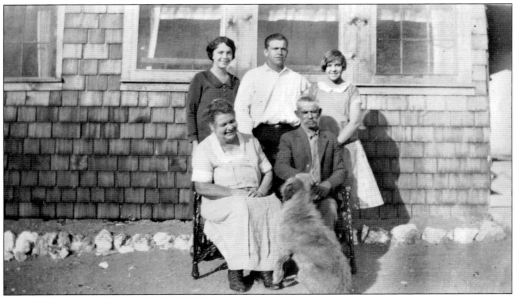

In this Phelps family portrait, from left to right, siblings Edna, Louis, and Irene pose behind their parents, J. Ernest and Wilmina Phelps, along with the family dog, Spot.

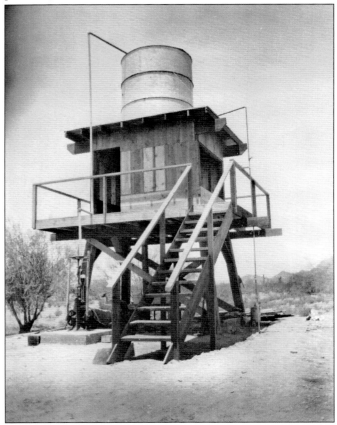

This water storage tank was located at the Phelps home. With no rights to canal water, the Phelps family had to haul water from Sixteenth Street and Camelback Road for home use.

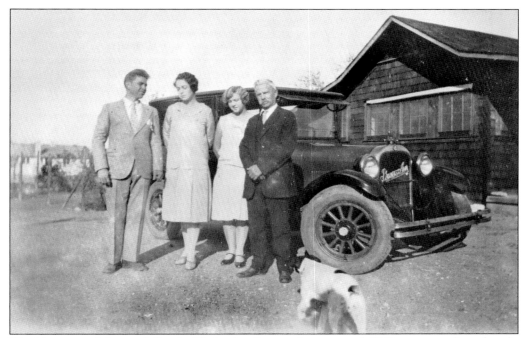

The big event of the week for the Phelps family, seen here around 1930, was attending church. Edna said, "sometimes we attended three services each Sunday: First Presbyterian in downtown Phoenix in the morning, then 2:30 and 7:00 p.m. services at the [Sunnyslope] Desert Mission, sponsored by 1st Presbyterian."

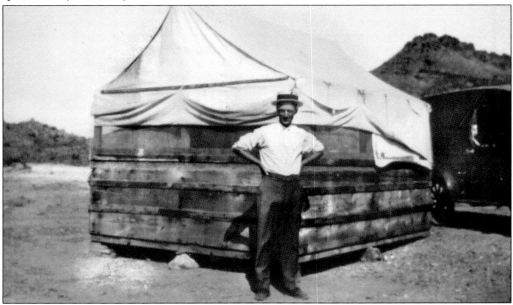

Following military service on the US–Mexican border at Camp Harry J. Jones, Charles H. Abels served with the American Expeditionary Forces in France (1917–1920). In 1921, the disabled, discharged veteran was unable to find a job. He remade his life in healthful Arizona, starting with a tent house on his 80 desert acres to the north of the Sunnyslope subdivision, called Cactus later.

Charles and his wife, Elenora, upgraded to a two-room house by "scrimping and saving." There were no glass windows, only openings with canvas flaps that afforded shade. The Abelses had two other cabins built nearby as rentals.

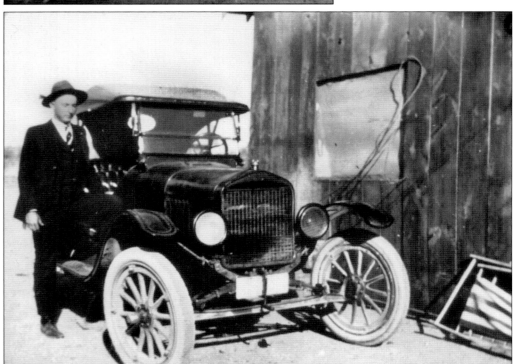

In 1921, Arizona's healthful climate drew Charles H. Abels (March 9, 1899–August 8, 1989) to Sunnyslope, where, for 65 years, he was a feisty but respected businessman and state legislator. He is shown here with his 1915 Ford Model T, which he purchased used in 1921 for "one hundred and fifty dollars on credit," as he later wrote.

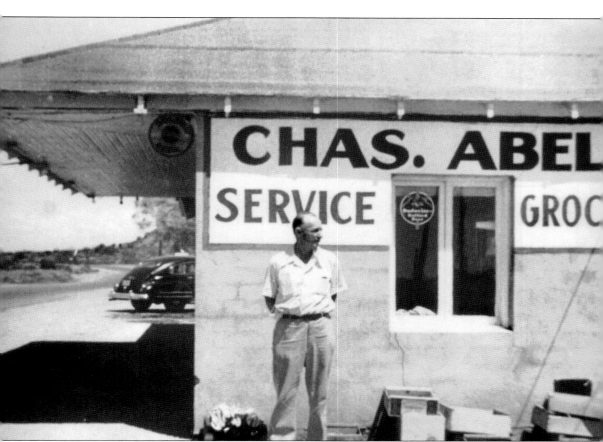

Abels's service station and grocery store was on the wagon road from Phoenix to Cave Creek, a small mining town some 20 miles to the north.

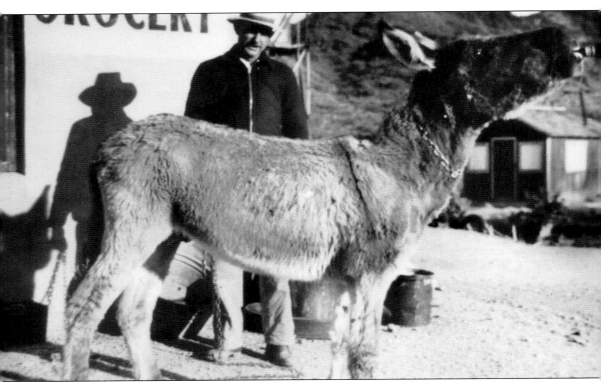

A beer-drinking burro named Jimmy was the star attraction at the service station. He would get the bottle in his mouth, toss his head up and down until he had emptied the bottle, then bray for more. Abels's service station and store was open seven days a week for over 30 years, closing only once a year on what Abels called "V-Day," always observed but not necessarily on the historic anniversary of the official May 8, 1945, event.

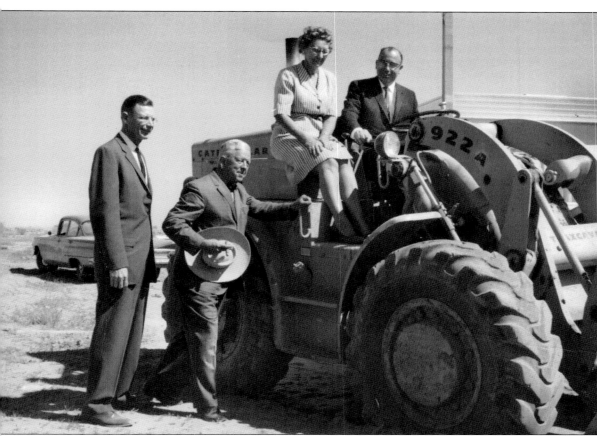

The first person to represent the Sunnyslope community after it was annexed by Phoenix in 1959, Edna McEwen served as Phoenix City councilwoman from 1960 to 1966. Shown here at the 1963 ground-breaking for a filtration plant at Northern and Thirty-fifth Avenues are, from left to right, Mayor Sam Mardian, council member Jay Hyde, and Edna Ellis on the equipment. The fourth person is unidentified.

This 1930s image shows Edna McEwen Ellis (left), community activist and author of *Sunny Slope: A History of the North Desert Area of Phoenix*. Edna came to Sunnyslope in 1929 with her husband, George McEwen, and their son Jack. After the death of her husband, she married local businessman E.D. Ellis in 1964.

# *Three*

# DESERT MISSION

Sunnyslope in the 1920s was considered by many as a place to shun—the abode of sick people whose germs were contagious. Into this situation came Marguerite Colley and Elizabeth Beatty, compassionate newcomers themselves, who wanted to help, to ease the pain, and to provide services to the needy. Working together, they became affectionately known as "Angels of the Desert," and stories are still told of how the two women could be seen crossing the desert at night with their flashlights to assist a sick one in need.

Others became involved. Beatty and Mrs. Evert Williams, a convalescent who lived in Dreamy Draw, formed the Sunny Slope Aid Society in 1929, and the Friendship Circle of Washington Women's Club and the Mission Circle of First Presbyterian Church began sponsoring Colley's home visits. Three Presbyterian missionaries, W.D. Himebaugh, J.N. Hillhouse, and Harvey A. Hood, and the First Presbyterian Church of Phoenix were integral to the humanitarian effort in Sunnyslope that blossomed from 1920 to 1939 into a faith-based medical facility called Desert Mission.

Contributions for the work came from across the nation as well as locally. Nine buildings eventually comprised the complex that grew up at Eva and Fifth Streets: McCahan Memorial Chapel (the first one built on-site in 1927), William Wrigley Jr. Recreational Hall, Knights of the Round Table Library, Pierce, Osborne, and O'Malley Cottages, the combined McCahan-Illman Cottage, and the Health Center.

By the late 1930s, the community project had been so successful that it was becoming an unwieldy operation. Staff members were growing into retirement or new jobs. After almost two decades, Desert Mission began to amicably evolve into two separate entities, each with its own board of directors. The medical component continued operating the facilities, at first as a member agency of the Phoenix Community Chest and later independently. In 1939, the religious portion separated from First Presbyterian Church in Phoenix and organized as the Desert Mission Presbyterian Church. A new phase of life for both organizations was on the horizon.

Marguerite Colley (left) came to Sunny Slope in 1919 with her husband, William, and their one-year-old, asthmatic son and was soon visiting other ill desert families, many who were indigent and lonely. Of the Sunny Slope population, a staggering 90 percent had tuberculosis, and 10 percent had asthma. Besides caring for her own family, she used her practical nursing skills for her neighbors, and drove many miles at her own expense on errands of mercy. With her little black bag and cheerful presence, Marguerite was of great comfort to many.

The Desert Mission saga began when Elizabeth Beatty, a retired secretary from Pittsburgh, combined her altruistic efforts with Marguerite Colley's. In the early 1930s, the benevolence of these two "Angels of the Desert" was greatly enhanced when John C. Lincoln—millionaire, inventor, and philanthropist—and his wife, Helen, became interested. Permanent good for the community of Sunny Slope was initiated. Pictured here in the 1940s are Elizabeth Beatty (left) and Helen and John C. Lincoln.

When warm-hearted Elizabeth Beatty first arrived, she lived on the south side of the Arizona Canal, but soon she realized the plight of the desert families across the canal. She was particularly concerned about the educational welfare of the children. She attempted to get books for them and started efforts to get a Sunday school established. She had inherited a large home at 8620 North Central Avenue (shown here) that she donated to Desert Mission as a Presbyterian manse when she moved later to Beatty Court, north of the canal.

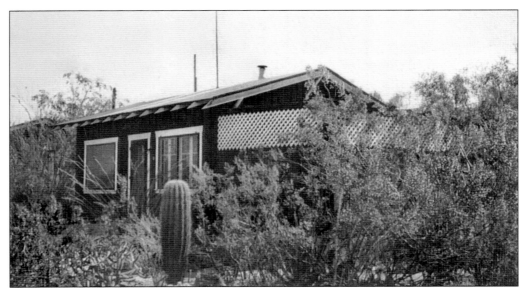

Located north of the Arizona Canal at Central Avenue and Ruth Street, the cluster of small cabins was named for Elizabeth Beatty, who utilized them as affordable rentals for her "beloved" Sunny Slope residents. Beatty persisted with her services for the Sunny Slope community until forced by poor health to discontinue them. In 1955, she died at Desert Mission Convalescent Hospital at age 86. Pictured here is a typical Beatty Court home.

Colley, pictured here around the early 1930s with a tuberculosis patient, was allowed to dispense medications as instructed by various doctors via the telephone.

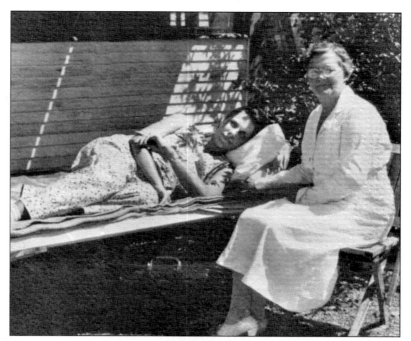

On her first report as visiting nurse, Colley noted she had been given "the magnificent sum of four hundred and fifty dollars," with which she purchased food, shoes, clothes, and medicine. Later, Maricopa County agreed to provide free medicine, including morphine, dilaudin, and codeine, as well as cod liver oil, aspirin, liniment, and cough syrups. Here, Colley delivers a food box to an appreciative family.

Marguerite Colley continued serving the community for many years, resigning from Desert Mission when she was 75. She had served 15 years in the field of nursing and 15 as a social worker, and she said she loved "every minute of it. . . . The work was hard and much of it was night work, but I enjoyed doing my bit and those years were the happiest of my life as I felt I was in the right place at the right time." She is shown here working at Desert Mission's food bank in the 1960s.

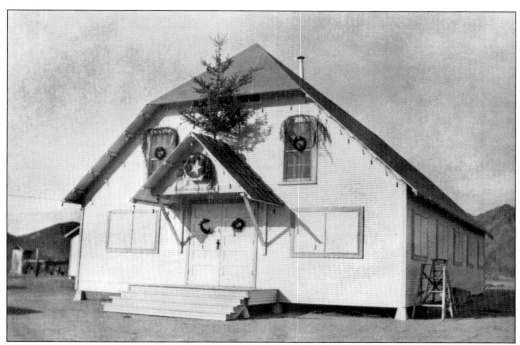

McCahan Chapel, the first church in Sunny Slope, was built with volunteer labor in 1927. Three sponsors made this possible: Sarah McCahan of Philadelphia with funds for the permanent building and Nancy and Clarence Gould, who donated the site—two lots on the northwest corner of Eva and Fifth Streets. The original building was destroyed by fire in 1942.

Dedication of the McCahan Memorial Chapel was on October 2, 1927, as a part of what is now officially known as Desert Mission. Rev. Joseph Hillhouse, a Presbyterian missionary, was named as the first director, a position he retained until 1938. For the next 10 years, Rev. Harvey A. Hood served in that capacity, followed by Herbert Hancox, who continued until his retirement in 1966.

## DEDICATION

### OF

## McCahan Memorial Chapel

### AT

#### SUNNY SLOPE

### Sunday, October 2, 1927

#### 3 P. M.

Prelude ............................................................ Orchestra

Invocation ................................... Rev. B. Wrenn Webb, D. D.

Hymn

> The Church's one foundation
> Is Jesus Christ her Lord;
> She is His new creation
> By water and the word;
> From Heaven He came and sought her
> To be His holy bride;
> With His own blood He bought her.
> And for her life He died.
>
> Elect from every nation,
> Yet one o'er all the earth,
> Her charter of salvation
> One Lord, one faith, one birth;
> One holy name she blesses,
> Partakes one holy food,
> And to one hope she presses,
> With every grace endued.
>
> 'Mid toil and tribulation,
> And tumult of her war,
> She waits the consumation
> Of peace for evermore;
> Till with the vision glorious
> Her longing eyes are blest,
> And the great church victorious
> Shall be the church at rest.

Selection ............................................................ Quartette

Scripture Reading:—Psalm 122.

Selections ........................... Rev. Roy O. Bancroft and Juniors

"Looking Backward" ........................... Mr. W. D. Himebaugh

Solo ........................................... Mrs. Ruth Swinney

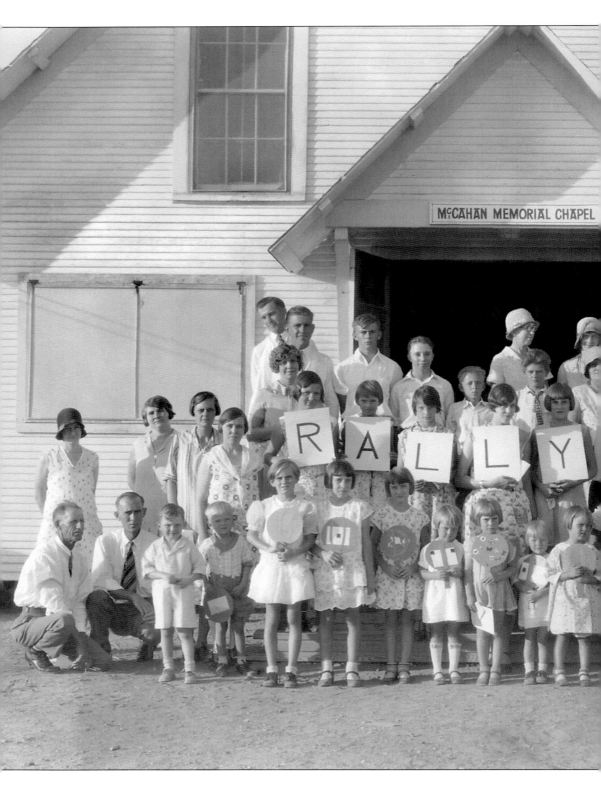

Sunday school students and teachers pose in front of McCahan Memorial Chapel for Rally Day in the 1930s.

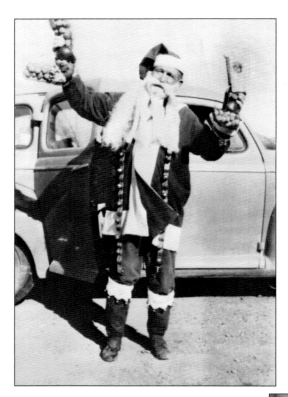

Frank Hilgeman, a local rancher dressed as Santa Claus, delivered many Christmas baskets to needy families in his decorated truck. He volunteered many years with Marguerite Colley and Elizabeth Beatty in their benevolent work.

A Sunday school had been meeting since 1925 in the convalescent two-room home of the Goulds. It was organized by W.D. Himebaugh, a lay Presbyterian missionary who traveled in the early 1920s throughout Arizona by horse and buggy. He started more than 200 Sunday schools that grew into Presbyterian and other churches. Pictured here are Mr. and Mrs. W.D. Himebaugh.

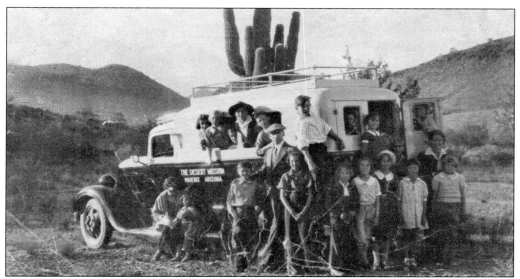

In 1930, on one of his annual travels across the country, Reverend Hillhouse persuaded Dodge Motor Company officials in Detroit to design a special van that could be an ambulance as well as a bus for youth trips. A favorite recreational destination was the White Mountains in eastern Arizona.

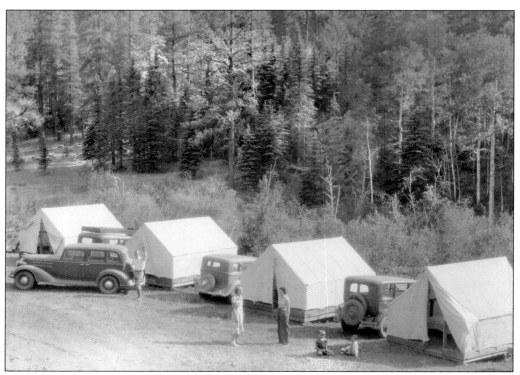

Near Greer, Arizona, Montlure Presbyterian Church Camp has been a special place for over 75 years. The only time summer camps have not been held there from 1931 to the present was from 1941 to 1945 due to World War II.

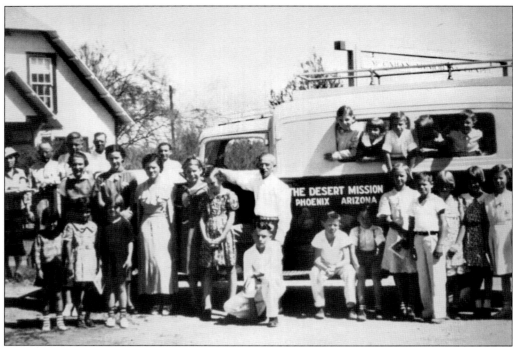

Joseph Hillhouse is seen here in the 1940s with Desert Mission folks on an outing. Hillhouse is in white at the center of photograph; George Vest, also in white, is one of the youths seated in front. Vest is a member of the original Loyal Order of the Desert Rats (LODR), an ad-hoc youth club in Sunnyslope, and a member of the Sunnyslope Historical Society.

The Osborne Cottage, built in 1929, housed the first real medical clinic in the area. One room was furnished with dental equipment, donated through Reverend Hillhouse's efforts. Dr. Fred Holmes and his associates, brothers Howell and Victor Randolph, were doctors who worked with those suffering from respiratory diseases.

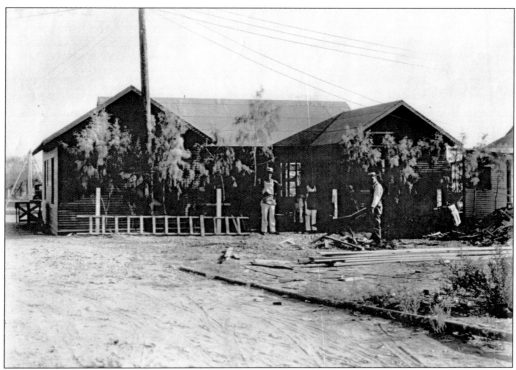

The McCahan-Illman Cottage was built in 1930, and a nursery school was housed there in 1939. Funds were donated for this cottage (along with money for movie equipment) by Mr. and Mrs. Illman. Below, the Illman Cottage is pictured a few years later.

Patients are seen resting at one of the Desert Mission cottages in the above image. Below, nurses make a call on patients in front of McCahan–Illman Cottage. The Desert Mission board of directors gave approximately five acres of land at Hatcher Road and Second Street to the Sunnyslope Presbyterian Church in 1949, and a new church building was constructed that year. Operations of Desert Mission and the church were separate, and each had its own board. The 1949 population of Sunnyslope was 8,000, significantly larger than the 1946 population of 2,500.

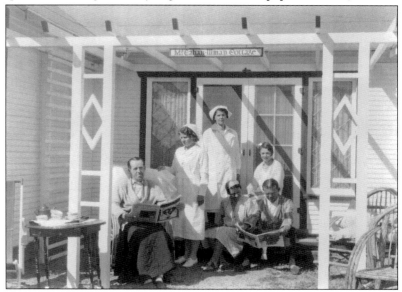

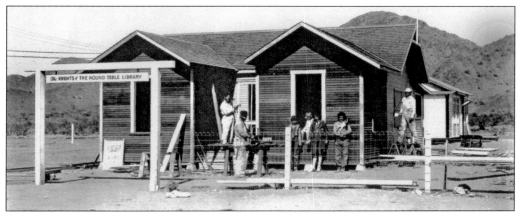

Knights of the Round Table Library was the first library in Sunnyslope. It was constructed in 1929 on the Desert Mission site at 350 East Eva Street. Contributions from the Knights of the Round Table in Brooklyn, New York, helped with building construction. That fraternal organization provided other gifts, such as the slide for the playground. This was the only library in the area until Acacia Library, a branch of the Phoenix Public Library system, was built in January 1969 on Townley Avenue, east of Seventh Street and south of Dunlap Avenue.

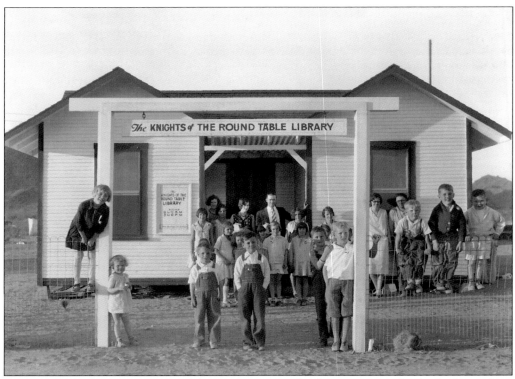

In 1924, Elizabeth Beatty contacted the Washington School District to get books for Sunnyslope youngsters. School district personnel were reluctant but finally did provide some textbooks that were soiled, tattered, or ready to be discarded. Fearful of tuberculosis germs, a school spokesperson told Beatty that the books should not be returned but burned when they were no longer needed.

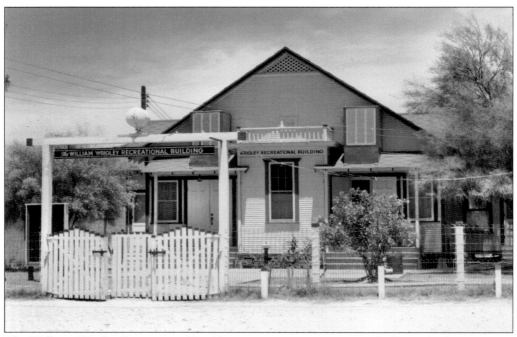

The William Wrigley Recreational Building, a community recreation hall, was built in 1930 on donated land by D.W. Bergstrom. Wrigley Hall was erected by volunteer labor with funds provided by William Wrigley Jr. in 1930. At that time, almost 700 people lived in Sunnyslope, and Desert Mission had become a community center.

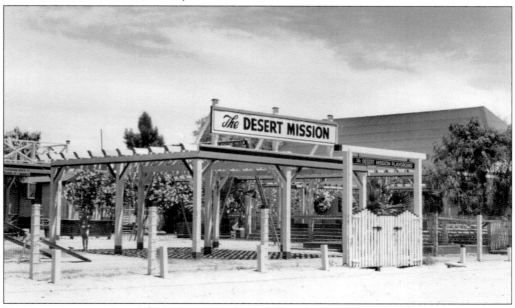

The Lincolns contributed $2,000 and Sarah McCahan $1,000 for purchase of Olney Tract, 20 acres between Dunlap Avenue and Wabash (now Hatcher Road) from Walnut (now Second Street) to Chestnut (now Third Street), and deeded it to Desert Mission. The Desert Mission building and playground are shown here.

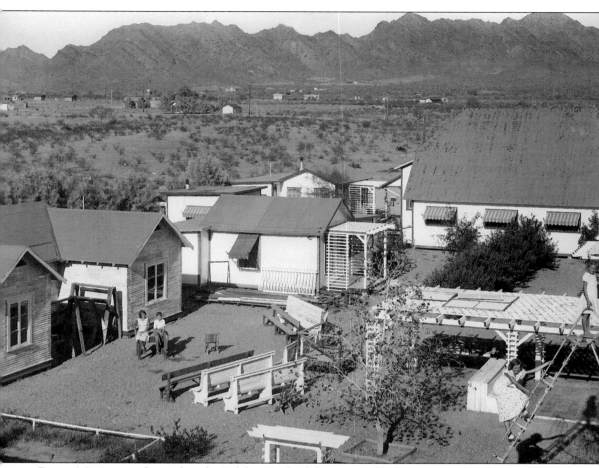

Desert Mission was located in the Salubra-Erial subdivision on land once owned and platted by Ralph and Eva Caron. The mission property measured slightly over 660 by 330 feet long, with nine buildings on the site, listed as follows: McCahan Memorial Chapel (forerunner of present-day Sunnyslope Presbyterian Church); William Wrigley Jr. Recreational Hall; Knights of the Round Table Library; Pierce, Osborne, and O'Malley Cottages for patients; McCahan-Illman Cottage, used for a nursery and daily therapeutic arts and crafts; and the Health Center, used to manufacture and display mission-crafted pottery. By October 1930, construction on the property was completed. Mrs. A.C. Armbruster (Louise) planned and supervised the landscaping of the original barren grounds. Here is an aerial view of some Desert Mission buildings looking northeast toward the Phoenix Mountains.

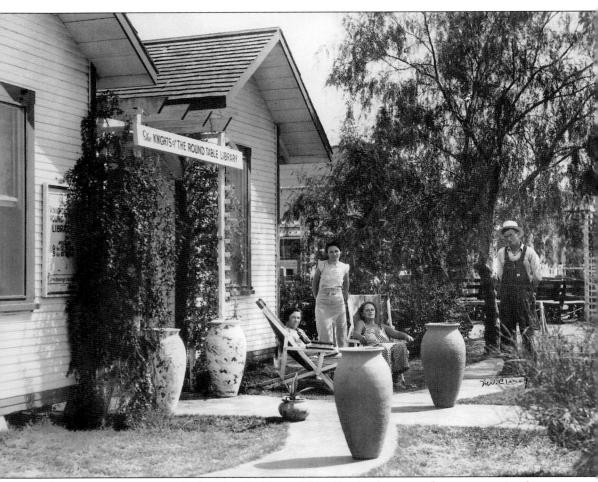

Large pottery items were displayed at the library. Using Portland cement, the pottery project began in 1932 but proved to be too damp and heavy for tubercular patients and so was abandoned after the first year. Reverend Hillhouse, visiting the Ozarks in Missouri, met the inventor of the pottery process, Ernest Horein, and thought that pottery making would be therapeutic for the patients. Horein came to Phoenix and helped get the program started for the Desert Mission.

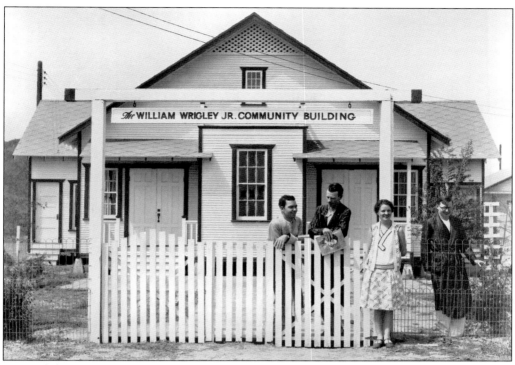

Pictured above are a visitor and three patients at Wrigley Hall, which was utilized as a community recreation center. The shallow wading pool seen below was part of the original Desert Mission complex and popular with the youngsters.

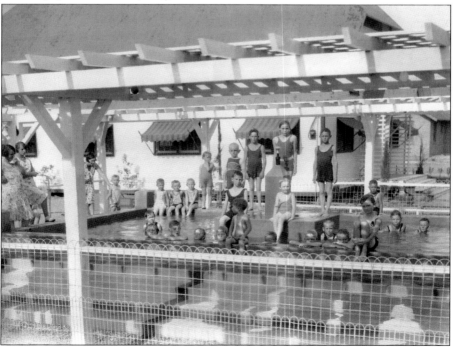

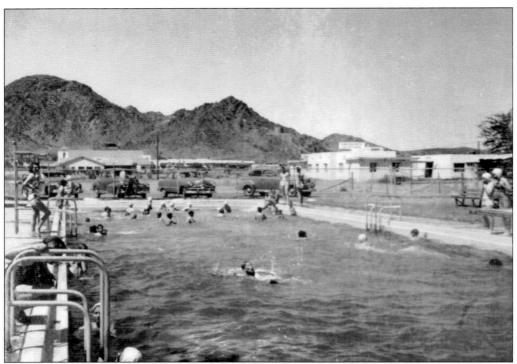

The Desert Mission swimming pool was built in 1947. It was located at Second Street and Dunlap Avenue on the John C. Lincoln property. The Sunnyslope Junior Chamber of Commerce had organized the same week, and for its special project it adopted the swimming pool. This pool served the community until 1958, when Lincoln had plans for a shopping center. The Sunnyslope Plaza Shopping Center was later built on this site. In 1965, the City of Phoenix built a city pool on Dunlap and Third Avenues. This pool is still in use today.

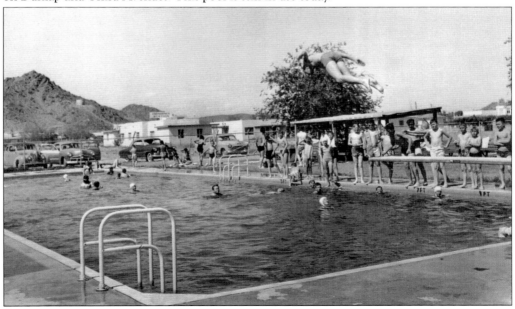

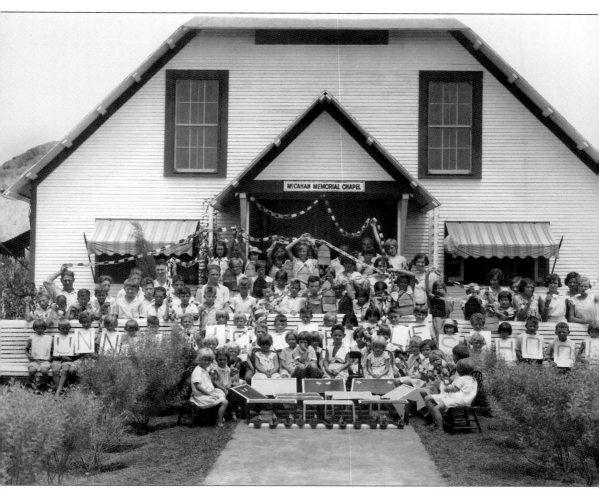

It is not possible to read the placards the children are holding, but this photograph seems to portray some type of Sunday school celebration, similar to typical summer-held vacation Bible schools. Children in the other four rows are holding a long paper chain with lanterns at intervals.

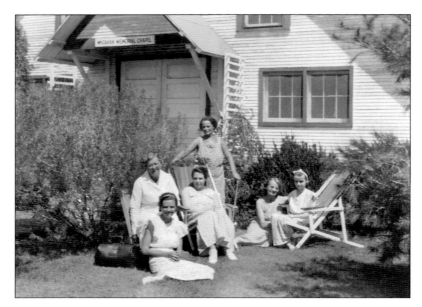

Marguerite Colley, on the left, is seated with black bag nearby and her daughter on the grass as she visits with some young female patients who are benefitting from the plentiful Arizona sunshine.

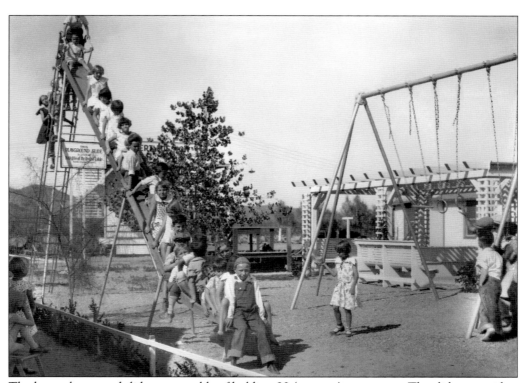

The huge playground slide was capable of holding 20 (or more) youngsters. The slide was said to be the tallest in the area.

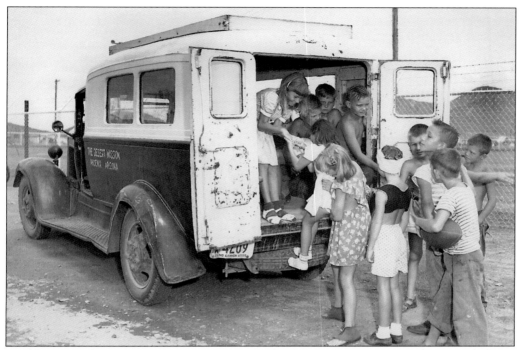

In addition to taking youngsters on group outings, the Desert Mission van served as an ambulance to transport sick patients to the clinic or hospital for medical treatment or was used as a truck to move people and equipment as needed.

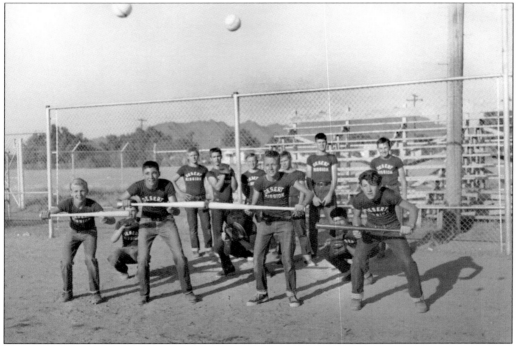

Pictured here is a bunting session for the Desert Mission softball team.

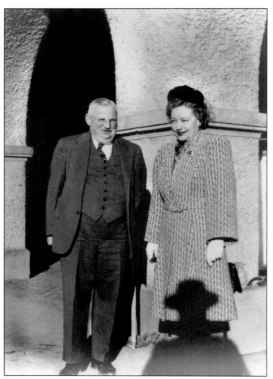

Clara Beatrice and Harvey A. Hood posed for the photograph at left. Reverend Hood was the second director of Desert Mission, serving from 1938 to 1948.

In 1942, all the buildings at the Desert Mission were destroyed except the library and Wrigley Hall. The loss was estimated at $22,000, but there were no injuries or loss of life.

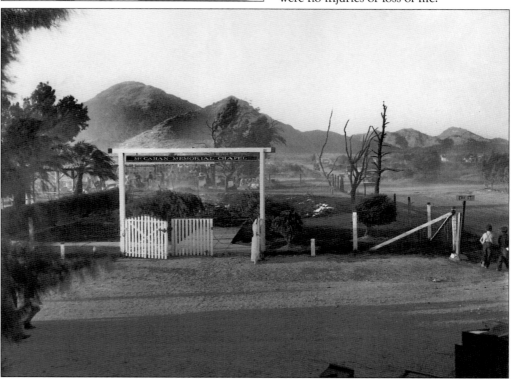

Ellen Ekeland was Desert Mission's first registered nurse. She arrived in Phoenix by train from Chicago on February 1, 1939, in response to the request of Dr. Harvey A. Hood, the newly appointed administrator of Desert Mission. A graduate of Presbyterian Hospital in Chicago, Ekeland worked in the Chicago area for a number of years with the Infant Welfare Society and with Rush Medical College. When a routine tuberculin skin test indicated a positive reaction, she entered a Chicago sanatorium as a patient, later becoming a staff member. She was recovering her health when Dr. Hood called her to come to Arizona.

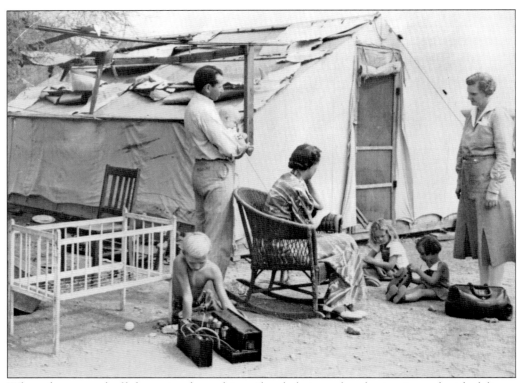

When she stepped off the train, dressed in a "lovely beige-colored suit trimmed with delicate bands of fur," Ellen Ekeland was appalled, according to her friend Edna Phelps. The "heat of that October day wilted her spirit as well as her body," and she considered buying an immediate return ticket to the Midwest. But her welcome by Desert Mission representatives was so cordial and enthusiastic that she determined to stay "for a time." Pictured here is Ekeland taking medicine to a desert family.

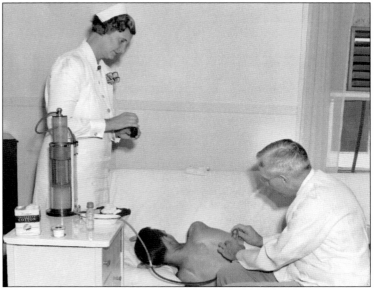

Phoenix doctor Fred Holmes, MD, became Ekeland's private physician when she arrived in Arizona. At Desert Mission, she discovered that the part-time physician there, George Thorngate, MD, had left on a missionary journey and would not be returning to the Sunny Slope work. Pictured here are Ekeland, Holmes, and a patient.

According to Edna Phelps, who became her friend in Sunny Slope, Ellen Ekeland's "future was sealed in those first few weeks," as her sympathetic heart was touched by the poverty, pain, illness, and loneliness that she saw at every turn. Each week as she had an appointment with Dr. Fred Holmes, Ekeland talked about the desert health-seekers and their need for medical attention. Through the persuasive efforts of Ekeland and Dr. Hood, Holmes finally agreed to be the mission's resident physician. Ekeland is seen here with a Desert Mission patient.

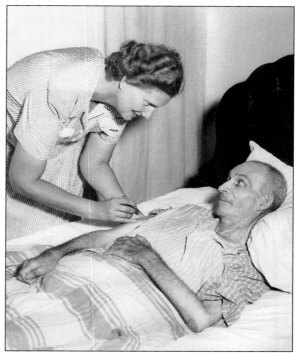

In 1942, Ekeland was introduced to Fred Cooke, a New York bachelor who was convalescing in Sunnyslope. They were married in June 1942, and the union lasted until Cooke died 23 years later in 1969.

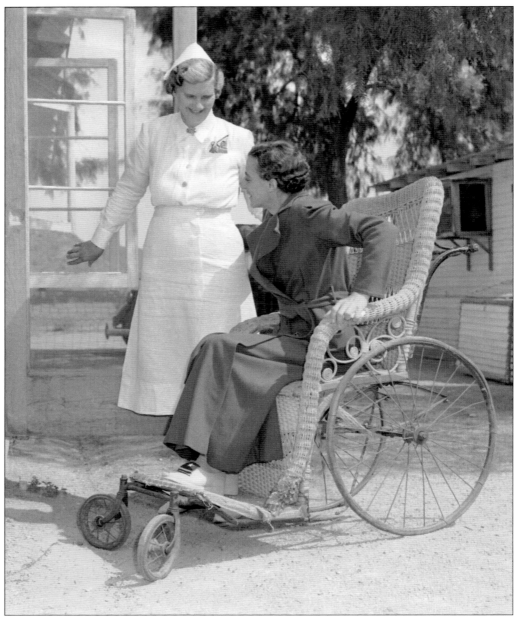

Nurse Ellen Ekeland is seen visiting another patient. The wheelchair pictured here is presumably still in the historical collections of John C. Lincoln Hospital, the successor of Desert Mission's medical clinic. Ellen Ekeland Cooke left Desert Mission in 1949 when administrators changed. She went to work as a school nurse in the fledgling Scottsdale School District, which at that time had 800 elementary students and 250 in high school. She retired in 1965. She was a member of the Sunnyslope Presbyterian Church and the Hospital Auxiliary at John C. Lincoln Hospital, remaining active well past the age of 80. Ellen Ekeland Cooke died in May 1992, 53 years after arriving at Desert Mission.

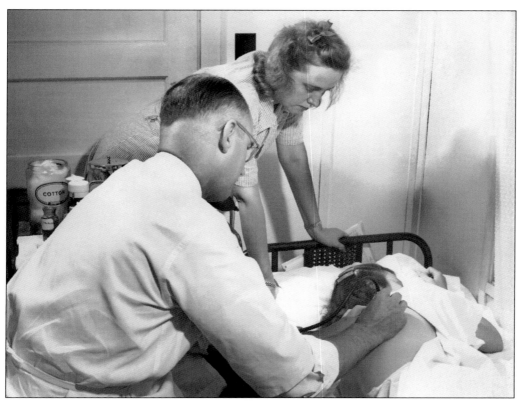

Bertram Snyder, MD, treats a patient at the patient's home. When Dr. Fred Holmes retired in 1944, Snyder, a Phoenix chest specialist, agreed to take over as head of the Desert Mission Clinic. In 1945–1946, he was involved in the construction of the Desert Mission Convalescent Home, built for the lodging and care of needy persons. In 1947, a new outpatient clinic replaced the old one in Osborne Cottage. When the medical component of Desert Mission became John C. Lincoln Hospital, Dr. Snyder helped with its incorporation, served several terms as chief of staff, and remained on the hospital board the rest of his long life.

Bertram Laurence Snyder was born in Norwood, Ohio, on April 5, 1911. He graduated in 1933 from Denison University in Granville, Ohio, and did his medical training at the University of Cincinnati College of Medicine. In his senior year, he contracted tuberculosis, diagnosed his condition, and went to the Dunham Tri-County Tuberculosis Sanatorium for recovery. In 1942, he moved to Arizona, where he was the personnel physician for Air Research Manufacturing Company in Phoenix and opened a private practice in internal medicine.

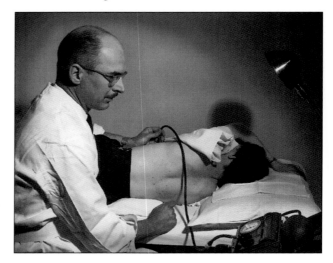

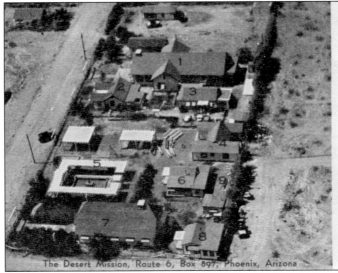

MADE from an airplane while flying high over the desert of Arizona, this photograph shows the cluster of buildings which make up The Desert Mission.

•

1. Wm. Wrigley Hall
2. Mission Library
3. Pierce Cottage
4. Illman Cottage
5. Wading Pool
6. Osborne Cottage
7. McCahan Chapel
8. O'Malley Cottage
9. Mission Craft Pottery

The Desert Mission, Route 6, Box 897, Phoenix, Arizona

Desert Mission had a postcard created in early 1930 to acquaint potential donors with its work. The front shows an aerial view of the Desert Mission site, showing the location of all nine buildings, including William Wrigley Hall, the mission library, Pierce Cottage, Illman Cottage, the wading pool, Osborne Cottage, McCahan Chapel, O'Malley Cottage, and Mission Craft Pottery.

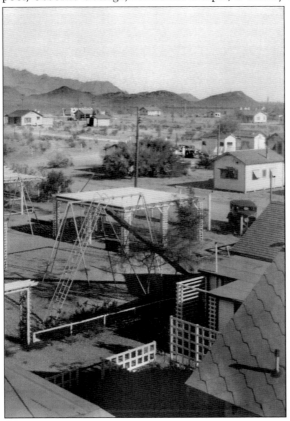

Here is a low-flying aerial view of the Desert Mission site, showing a playground and the Phoenix Mountain Range in the background.

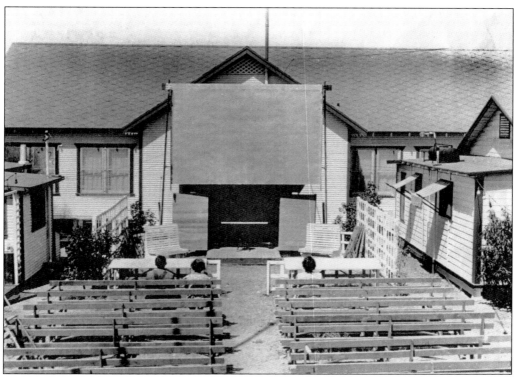

Outdoor movies were shown with the North Mountain Range in the background. The movie screen was located along east side of Wrigley Recreational Hall, with bleachers set up. More than 60 years later, Sunnyslope residents still talk about the extremely popular movie nights at Desert Mission. The building below was the projection house for showing outdoor movies.

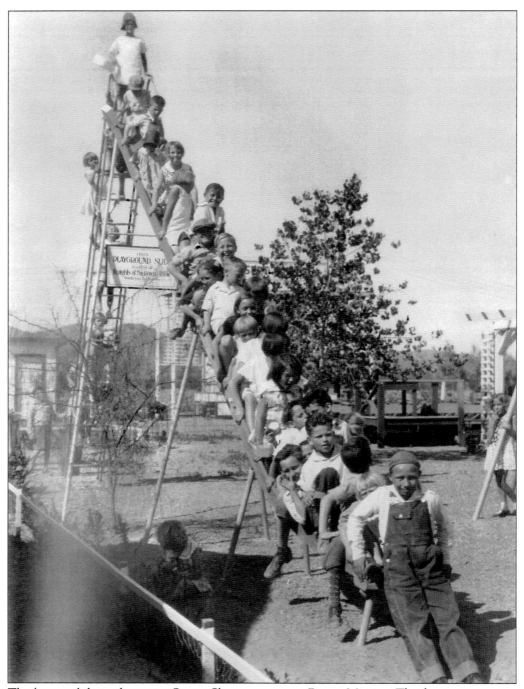

The largest slide in the entire Sunny Slope area was at Desert Mission. The four youngsters at the top of the slide are the Weaver children, who spent many hours at the mission. The slide was a gift from Knights of the Round Table.

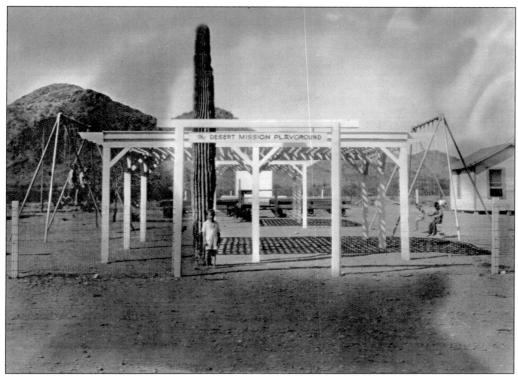

At the far side of the photograph, looking north toward the mountains, the outdoor movie screen can be seen. Movies were shown on Friday and Saturday evenings during summer.

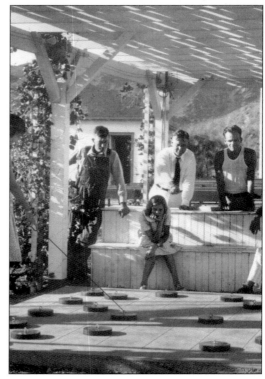

The checkerboard-shaded arbor on the Desert Mission ground provided a place for those who could not do strenuous exercise due to asthma or other respiratory ailments.

The Desert Mission football team competed with two other community teams, the Valley Heights team and Our Lady of the Wayside Catholic Church team, long before there was an area high school. They played at the ballpark between Second Way and Third Street on Dunlap Avenue in 1947–1948. The boys shown in this photograph, members of a Desert Mission team, have not been identified.

The Desert Mission softball team for younger boys played at the ballpark on Dunlap Avenue between Second Way and Third Street.

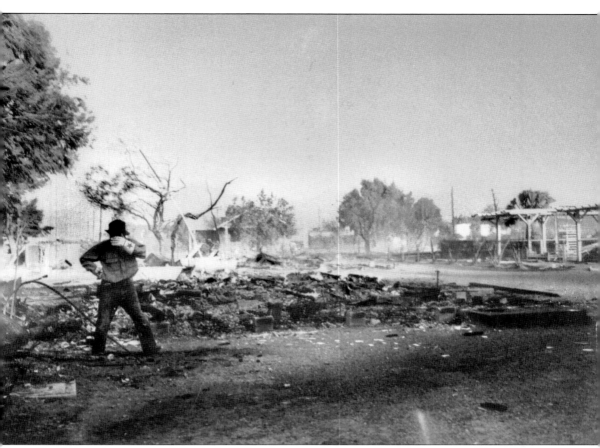

On the windy evening of March 6, 1942, a fire started in a small pump house on the northwest side of Desert Mission and swept to the southeast corner of the property. No assistance was immediately available except for nearby residents with garden hoses. A man stationed at the large water well kept pressure at a maximum, but the water was only sufficient enough to save the private homes. Seven of the nine mission structures, including McCahan Memorial Chapel, the Osborne, Illman, Pierce, and O'Malley Cottages, and the shade structures, were destroyed. Wrigley Hall and the Knights of the Round Table Library were saved. Fire loss was estimated to be $22,000, but there were no injuries or deaths as a result of the fire. The property was inadequate for rebuilding, so plans began to construct a new medical clinic on a 20-acre plot at the southeast corner of Second Street and Hatcher Road. This had been purchased from Nellie Olney in the 1930s with the assistance of Sarah McCahan and John and Helen Lincoln.

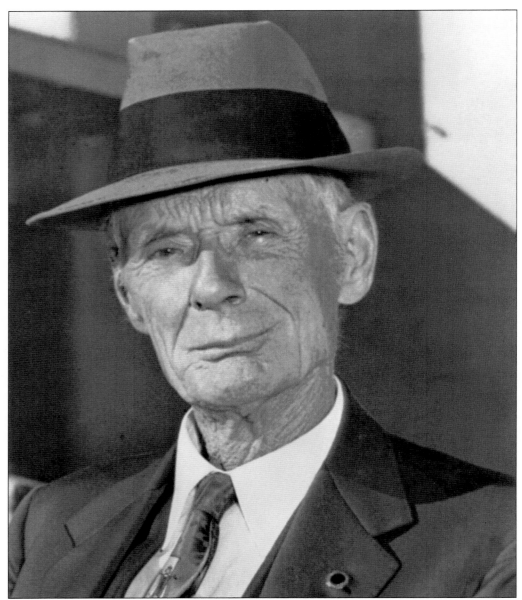

John Cromwell Lincoln was the self-made millionaire son of an abolitionist minister and his physician wife. A publicity-shy Ohio inventor and entrepreneurial contemporary of Thomas A. Edison, he left his mark particularly in Sunnyslope, Paradise Valley, Phoenix, and Scottsdale, Arizona. When Lincoln brought his wife, Helen, and their three children to Arizona, they made their home near Thirty-second Street and Camelback Road. At that time in the Phoenix area, land was cheap, and Lincoln bought 320 acres at $20 per acre in the area known as Paradise Valley. According to what has been written about him, Lincoln was convinced that Arizona had two assets—minerals and climate—that were destined to make it an important part of the nation. True to his nature, he immediately set out to promote them. John C. Lincoln gave generously to the Desert Mission and its expansions but modestly agreed to have the medical facility bear his name only at the strong insistence of his wife.

Helen Irene Colvill Lincoln was born in Shortcreek, Ohio, in 1891 and died in Phoenix, Arizona, in 1993. She was 25 years younger than her husband (his third wife) and was the mother of three children, Lillian, Joseph, and David Lincoln. After Helen Lincoln was diagnosed with tuberculosis in 1931, she recalls her husband "taking exactly six minutes to decide to make the move from Cleveland to Phoenix." Arizona was known for its clean air and warm weather, the right elements to help TB patients heal themselves in the dry climate. Helen was given just two years to live, and her decisive husband was willing to do whatever it took to change that prognosis. His quick decision was the right one, as Helen lived to see her 103rd birthday.

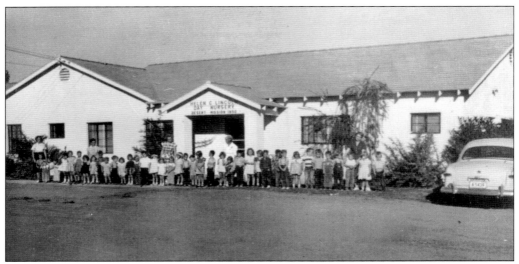

The Helen C. Lincoln Day Nursery was built in 1950 to replace the original Desert Mission building. It was located on Second Street just south of the Sunnyslope Presbyterian Church. After her husband died in May 1959, Mrs. Lincoln's personal support, as well as her financial contributions, continued for the Desert Mission, John C. Lincoln Hospital, and many other facilities around the state of Arizona until her death 34 years later.

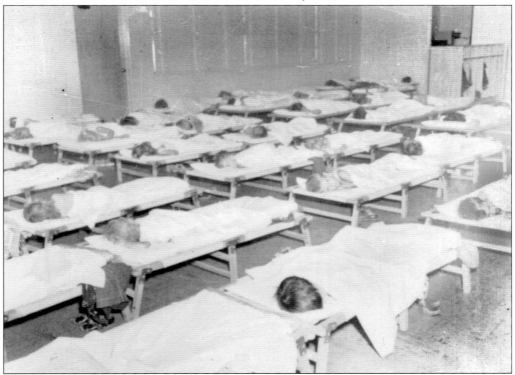

Inside the nursery, daily naps were taken on the many cots that were set up. The first nursery was started in 1937 for children of parents with tuberculosis so they could be away from the ill parent for a time. They were served hot meals and cots on which to rest.

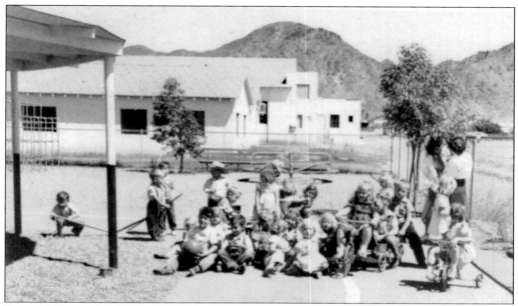

Pictured here is the playground of the Helen C. Lincoln Day Nursery, located at the rear of the building. Lillian Williams was the cook, manager, housekeeper, and caretaker for the children. The first location was a one-room building on the corner of Mission Lane and Fifth Street. Community Chest helped with the funding. She was interested in seeing that Desert Mission children were cared for with plenty of food and clothing to wear. She raised prize-winning goats, and it is said that she often would fill her car with food staples and goat milk to bring to the Desert Mission children.

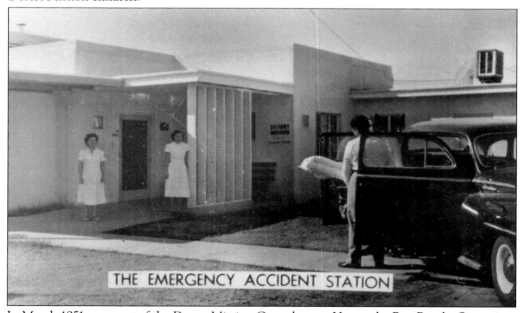

THE EMERGENCY ACCIDENT STATION

In March 1951, as a part of the Desert Mission Convalescent Home, the Roy Brooks Outpatient Clinic and the Emergency Station were organized and licensed by the Arizona Department of Health. Shown here is an emergency station near the Roy Brooks Outpatient Clinic.

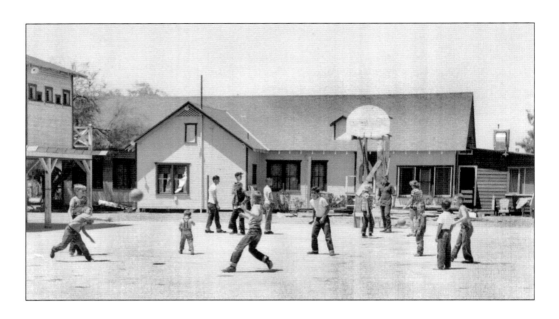

Providing recreational activities was a valued component of Desert Mission's work with children, especially making equipment such as basketball backboards available year around. A wading pool, later replaced with a large swimming pool, was a prime attraction for desert youngsters.

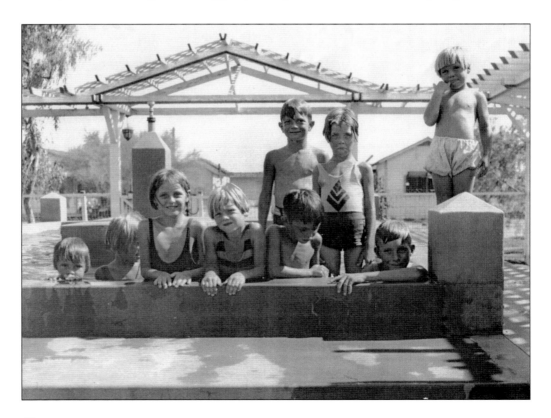

# *Four*

# WORLD WAR II
# AND BEYOND

Sunnyslope's population soared in the 1940s from 1,200 to 6,000 or so. Growth came because of wartime workers remaining in the area, veterans seeking inexpensive acreage for homes, plus the continuing stream of health seekers. No public schools existed until Sunnyslope Elementary opened in 1949. Until then, elementary students were bused to Washington Elementary School at Twenty-Seventh and Northern Avenues, and high schoolers rode city buses or provided their own transportation to Glendale or Phoenix Union High Schools.

Desert Mission continued to loom large in community life. As noted earlier, the Lincolns were financial supporters of the project and played key leadership roles. When a spark in the pump house started a mission fire, destroying the clinic in 1942, it was rebuilt and planning begun, but constructing a full hospital was held up until the war ended.

In 1951, Desert Mission Convalescent Hospital was built. Three years later, John C. Lincoln finally caved to pressure and allowed the hospital to be named in his honor. Desert Mission continued as a hospital department with programs that benefited the Sunnyslope community. In 1997, the John C. Lincoln Hospital merged with Phoenix General and became the John C. Lincoln Health Network, now widely known for four major hospitals, numerous primary care physician practices, urgent care centers, and specialty practices located throughout the Phoenix metropolitan area.

In addition to the 1949 Sunnyslope Presbyterian Church at Second Street and Hatcher Road, other churches were being established. They include Sunnyslope Baptist Church on Cave Creek Road (now North Mountain Baptist Church); Most Holy Trinity Catholic Church on South Seventh Street; the Church of God at Mountain View and Fifteenth Avenues (now Wesleyan Bible Church); and Sunnyslope Mennonite Church on North Seventh Street.

At least two weekly newspapers, *Sand* and *Sage*, published by Charlie and Lillian Stough, regaled readers with important, interesting, and fun news of Phoenix, the state of Arizona, and the unincorporated communities of Sunnyslope, Cactus, and Paradise Valley.

Sunnyslope tried four times to incorporate as a town but failed each time by a narrow margin. In 1959, the community was annexed by the City of Phoenix, and a new era began.

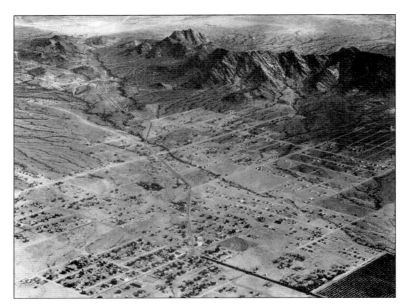

Looking north in this 1947 aerial photograph, Cave Creek Road can be seen as a winding dirt ribbon trending north-northeast from Five-Points (Dunlap Avenue, Seventh Street, and Cave Creek Road) to a low pass in the mountain range. From five houses in 1919, Sunnyslope population by 1947 had increased to 6,000 residents.

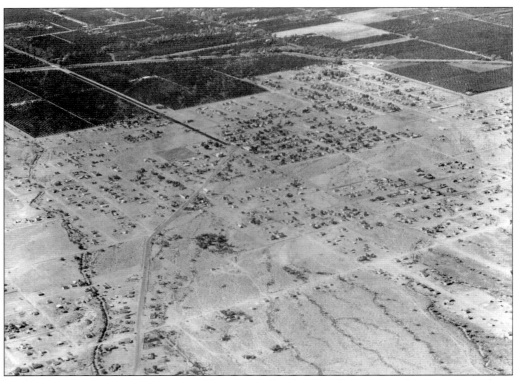

Looking southwest from Cactus along Cave Creek Road to Five-Points, note that some agriculture has spilled over the Arizona Canal to the north. The canal is the wide line running from left to right across the upper part of the 1947 photograph. Peoria Avenue is seen running left to right in the foreground.

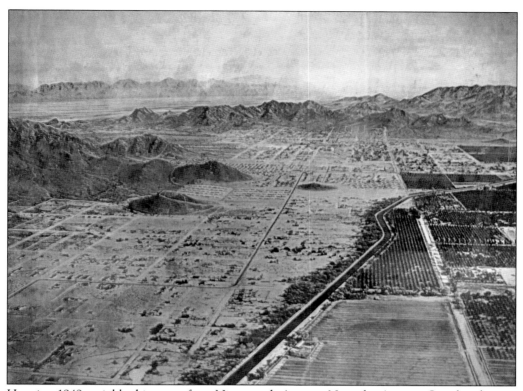

Here is a 1949 aerial looking east from Nineteenth Avenue. Note the Arizona Canal and citrus groves on the south side of the waterway.

Very similar to the previous aerial, this closer view was taken a few years later with more visible population growth. Notice Sunnyslope High School, which opened in 1953, is in place, adjacent to the north bank of Arizona Canal between Seventh Avenue (see marker) and Central Avenue.

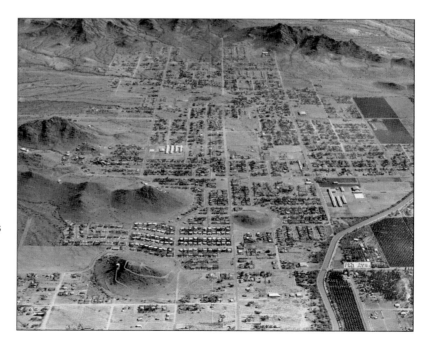

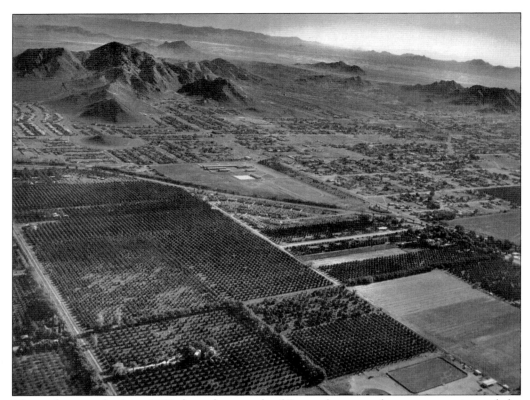

These photographs from 1954 show the growth of Sunnyslope as a desert community and the large agricultural district that is developing south of the Arizona Canal. The 1950 population was about 8,000; and by 1954, Sunnyslope was classed as one of the "most progressive communities" with "new homes, businesses, churches, and schools." (*Arizona Republic*, September 19, 1954.)

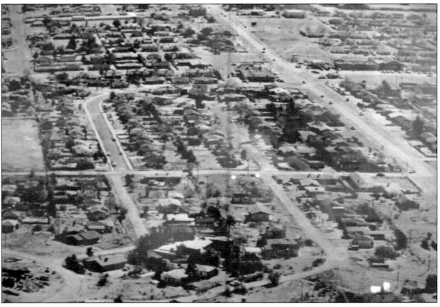

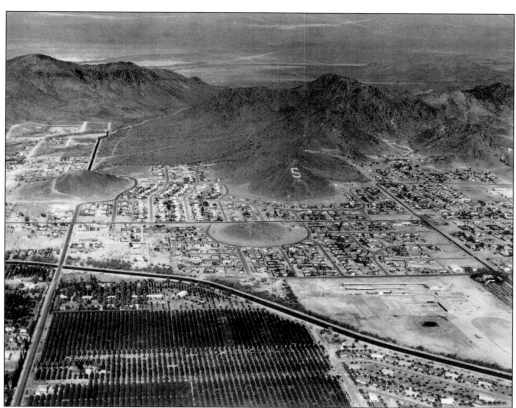

Sunnyslope High School, shown in the right foreground just north of the Arizona Canal, was two years old in this photograph, and its first graduating class (1954) had just painted a prominent S on one of the small peaks south of the Shaw Butte–North Mountain Range. The Arizona Canal in the lower part of the photograph is flowing from right to left.

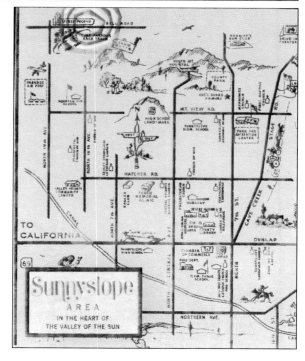

This map of Sunnyslope was published by Sage Press after its 1959 annexation by the City of Phoenix. Note the location of city facilities such as the post office.

Don't buy something you don't need for fear you will have to sell something you need to pay for it.

# ★ Sunnyslope Star ★

The Best Governed People Are The Least Governed.
—Thomas Jefferson

Friday, June 5, 1953      197 E. DUNLAP, SUNNYSLOPE, ARIZONA      VOL. 1, No. 9

# SUNNYSLOPE STILL UNINCORPORATED

## Thanks To The 824 Who Voted 'No'

Shortly after 6 p.m. Friday, May 29th, citizens of Sunnyslope, the fastest growing unincorporated community in the State of Arizona, received the tidings that Sunnyslope was still unincorporated and free to keep growing unhampered by machine politics.

The question of whether or not to incorporate was settled in the American way by ballot of 1484 people who went to the polls at the Sunnyslope Grade School cafetorium in orderly fashion — all through the day and cast their votes 660 to 824 against incorporation.

Due to the fact that many people had already left for the summer and the election also came on Memorial Day week end, the voting was lighter than it might have been at an earlier date. On May 24, 1949, date of the last incorporation election in which the move to incorporate Sunnyslope was ...

... the unincorporated community was losing thousands of dollars in state tax money which is at present divided among incorporated towns and cities. Opponents stressed that incorporation would mean the levying of additional real property taxes and that present plans for a complete reform in the state tax structure could overnight repeal tax refunds to incorporated communities.

The fight was carried up to the eve of election day with sound trucks touring the area asking taxpayers to defeat the move. Incorporators staged a parade Thursday evening.

Nine voting machines used in the balloting speeded up the count so that shortly after 6 o'clock the victorious group was parading the streets to let friends and neighbors know that incorporation had once more gone down to defeat.

## Sunnyslope To Improve Facilities

Plans for street and park improvements in the Sunnyslope area were announced yesterday by the county board of supervisors.

The twin improvement program, Hart said, was held in abeyance while residents of Sunnyslope voted on the question of incorporation. The proposal to set up a town government was defeated at the polls last Friday.

"W. J. Jamieson, county engineer, has completed plans to sealcoat the various county-maintained roads in Sunnyslope, including Central Avenue, Seventh Street, and Cave Creek Road," the supervisor said.

"Dennis McCarthy, county parks ...

## Expenses Sunnyslope Incorporation Voting Held May 29, 1953

| | |
|---|---:|
| Election Board Salaries | $243.00 |
| Election Board Meals | 36.00 |
| Machine Preparation 2 men | 96.80 |
| Printing | 87.75 |
| Supplies | 5.00 |
| Deliver & Pickup of Voting Machines | 72.36 |
| Total election expense | 540.91 |
| Petition Check | 439.52 |
| **Total Cost** | **$980.43** |

(Compiled by: Comptroller's office, Board of Supervisors June 1, 1953)

## Sunnyslope Does It Again

At 6 a.m. The people marched to the polls to wage their battle against: Dirty politics

Incorporation
More Taxes
Bankruptcy

At 12 a.m. Property Taxpayers were still marching in ...

---

# INCORPORATION FAILS IN SUNNYSLOPE

Vol. 1, No. 23 - Dec. 15, 1955

## SAGE
Cactus, Arizona

For the third time, the voters of Sunnyslope have turned down the proposal to become an incorporated town.

Unofficial returns Tuesday night showed 667 voters against incorporation, and 550 for. The quietest incorporation campaign in Sunnyslope history turned out no different from the rest. The community will remain unincorporated for the time being and may later vote on annexation to Phoenix.

## CHRISTMAS LIGHTS

All the main business sections of Sunnyslope glowed with Christmas lights and decorations this week. It was the first time that an organized effort had been undertaken to decorate the town in "city style" at Christmas time.

### THREE SECTIONS COMPETE

In a spirit of friendly competition the three main business sections raised their own funds from among themselves, each trying to outshine the other in the decorating accomplishment. Together, in the Sunnyslope Business and Professional Association they issued an invitation to Santa Claus and arranged for him to be present from 2 to 6 P. M., to talk with the children and hand out treats, according to the following schedule:

Dec. 12 - Central & Hatcher
Dec. 13 - Cave Creek Rd, near Dunlap.
Dec. 14 - Chamber of Commerce Bldg, on Dunlap.
Dec. 15 - Cave Creek Rd. & 8th.
Dec. 16 - Chamber of Commerce
Dec. 17 - Hatcher Rd. & 6th Ave.
Dec. 19 - Chamber of Commerce
Dec. 20 - Hatcher Rd. & 11th Ave.
Dec. 21 - Cave Creek Rd, near Dunlap.

(Cont'd on P. 23)

Sarah Lee Connor, Salad Bowl Princess, Sunnyslope High School
Photo - Eisenstein

## SAGE

*The only newspaper you can open up in a high wind - or read horseback -*

---

The *Sunnyslope Star*, the community's first newspaper, notes in the June 1953 headlines that residents, for the second time, have voted against incorporation, preferring to remain an unincorporated area of Maricopa County.

In December 1955, outspoken, civic-minded *Sage* editor Lillian Stough reported, "for the third time, the voters of Sunnyslope have turned down the proposal to become an incorporated town." The contest was close: 550 for and 667 against.

**CITY OF PHOENIX**
ARIZONA

April 28, 1959

To the New Citizens of the City of Phoenix:

We are happy to extend to you our most cordial greetings and a warm welcome as a new citizen of the City of Phoenix.

A city government exists only for the purpose of performing necessary municipal services for its citizens. It is our aim that the extent and character of such services be the best that your tax dollars can buy.

As a citizen you will have a voice in the affairs of the City, not only through the election of members of the City Council, but in participating in hearings before the Council and the various boards of the City. If you have registered to vote in Maricopa County you may vote in all City elections without further registration.

We hope you can help us with a series of "community meetings", patterned on the old Town Hall idea, that will enable you to meet members of your city administration and voice any questions and complaints that you might have.

As a City resident you are eligible for City employment provided you have lived in Arizona for a year. Applications for such employment may be filed with the Personnel Department in the City Hall.

Again we want to emphasize that we are proud to have you and your neighborhood as a part of the City of Phoenix. We feel that this is an important step toward a greater Phoenix. Remember we are your city government. Please feel free to call on us at any time for desired information or to suggest anything which will improve our city.

Sincerely yours,

PHOENIX CITY COUNCIL

*Jack Williams*
Mayor

PHOENIX, ARIZONA
ALL-AMERICA CITY

V. A. CORDOVA
Councilman

DR. JOSEPH MADISON GREER
Councilman

JOHN B. HALDIMAN
Councilman

DAVID P. JONES
Councilman

FAITH I. NORTH
Councilwoman

DICK SMITH
Councilman

After a total of four incorporation attempts (1949, 1953, 1955, 1958), Sunnyslope voter preference to remain an unincorporated county entity was no longer an option, and the community was annexed in April 1959 as a part of Phoenix. Mayor Jack Williams extended greetings to the "new citizens of the City of Phoenix." A sub-city hall office was established at 8900 North Central Avenue. A treasury department and office for issuing licenses went into the old Metropolitan Fire Department building at 8225 North Central Avenue. Longtime Sunnyslope resident Edna McEwen and L.F. McDaniels were appointed to serve on the Phoenix Adjustment Board.

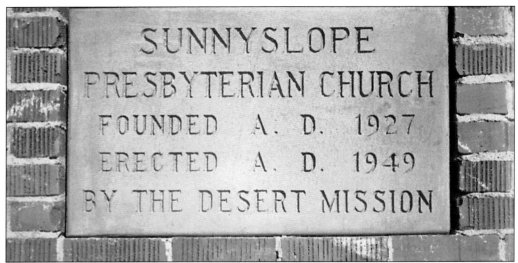

The cornerstone at the Sunnyslope Presbyterian Church at 9317 North Second Street was laid on March 20, 1949. The church began in 1927 as McCahan Chapel during the earliest days of Desert Mission. As the mission project evolved, so did the religious service. When the social-religious component of Desert Mission was separated in 1949 from the social-medical component, each had its own board of directors. The present-day building was erected on the five acres at Hatcher Road and Second Street that were deeded to the Sunnyslope Presbyterian Church later that year.

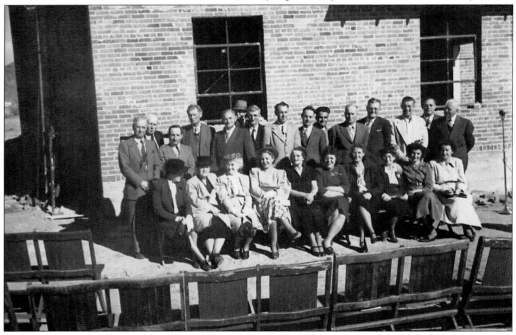

This group photograph of church members includes Helen and John C. Lincoln, who were part of the first congregation at Sunnyslope Presbyterian Church on the corner of Second Street and Hatcher Road. At a cost of $45,000, John McTaggart, the contractor, completed the construction in five months. Constructed of red brick, the building was 124 feet long and 50 feet wide, seating 400 comfortably. The first pastor was George Walker.

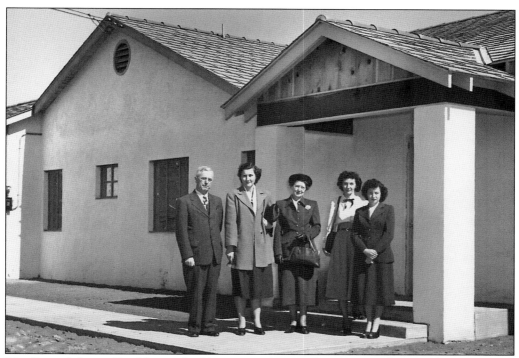

The Desert Mission Day Nursery building was constructed at 9301 North Second Street, just to the east of the Sunnyslope Presbyterian Church.

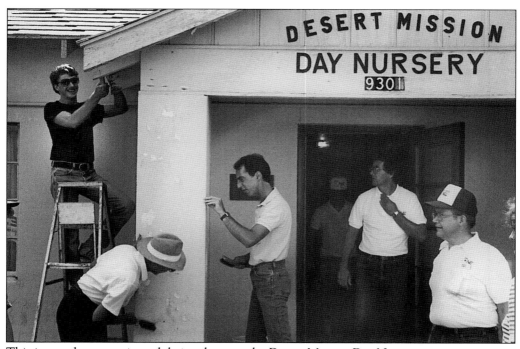

This image shows repair work being done on the Desert Mission Day Nursery.

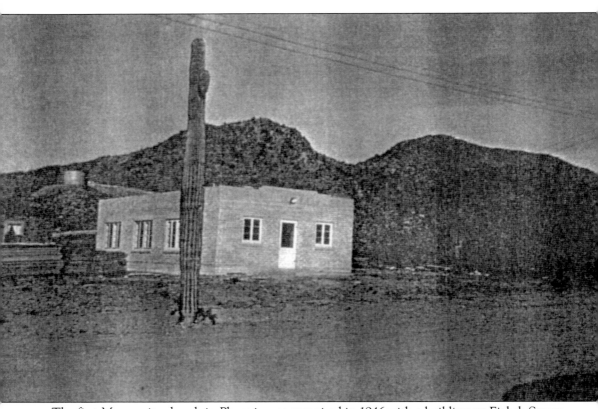

The first Mennonite church in Phoenix was organized in 1946 with a building on Eighth Street north of Peoria Avenue. The original church building still stands in back of the 1993 church, which is accessed from Seventh Street.

Here is the Sunnyslope Mennonite Church as it looks today, located at 9835 North Seventh Street. It was built in 1993.

In 1949, this building was erected as the Church of God at Mountain View Road and Fifteenth Avenue. It is pictured here more than a half century later. It now houses the Wesleyan Bible Church.

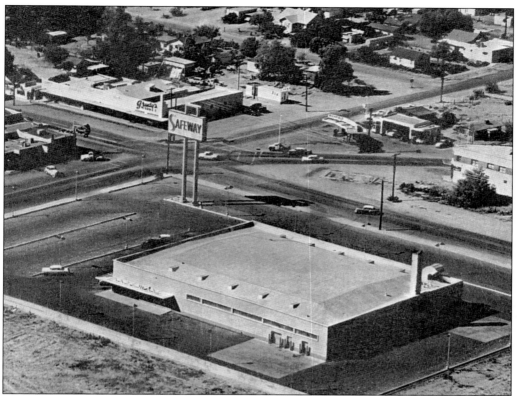

The intersection of Seventh Street, Dunlap Avenue, and Cave Creek Road was known as Five-Points in Sunnyslope. A Safeway grocery store was located on the southeast corner, Grady's Market (owned by Grady Auten) on the northwest corner, and Sunnyslope Drug Store on the southwest corner. This photograph was taken in the late 1960s.

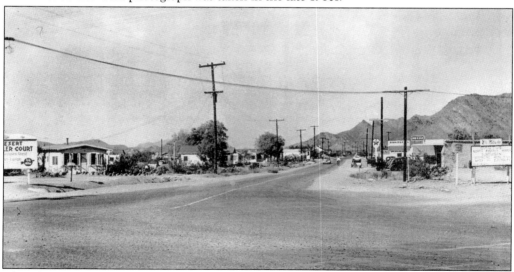

This photograph looks north up Cave Creek Road toward the Phoenix Mountain Range. The precise date is unknown, but the vehicles appear to be the mid-1930s or earlier.

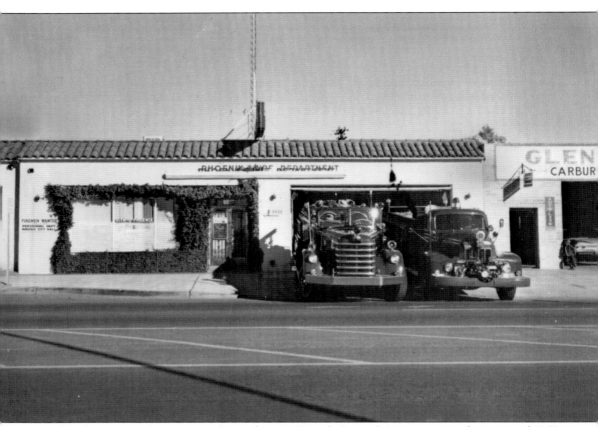

The Phoenix Fire Department, located at 8925 North Central Avenue, is seen here around 1959. In December 1947, the Arizona Corporation Commission granted a franchise to the Metropolitan Fire Department to operate a fire truck within a radius of two and a half miles of Central Avenue and the Arizona Canal. The fire service started on May 1, 1948, with owners Jack McCoy and Nick Pano. Subscribers to the service offered by Metro Fire paid a monthly fee. Protection was extended to schools, churches and public buildings without charge. Service continued on this basis until April 1959, when the Sunnyslope area was annexed into the City of Phoenix. The city entered into a contract with McCoy to continue fire protection to the newly annexed area for a nine-month period, at which time the city took over the service. In 1960, a new Van Pelt Class A pump truck with 1,250-gallons-per-minute capacity replaced the 1952 Chevrolet Class B pump truck that had only a 500-gallon-per-minute output. The fire department operated from the Central Avenue Station until Station No. 7 opened.

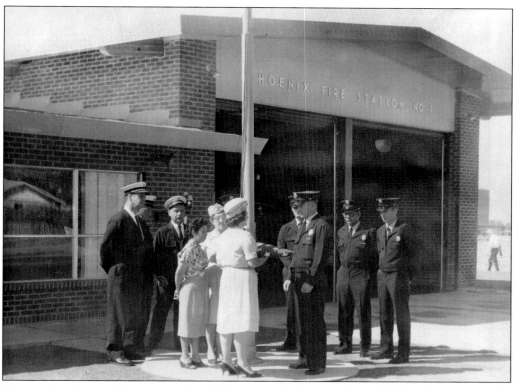

Phoenix Fire Station No. 7 opened in 1966 on Fourth Street and Hatcher Road.

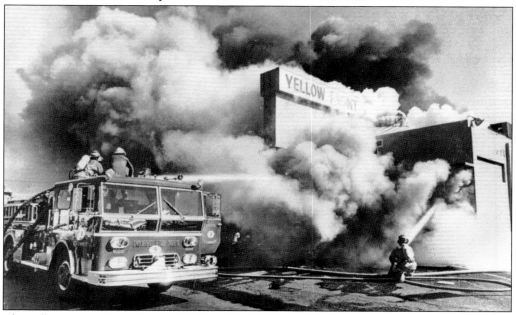

The Yellow Front Store on the southwest corner of Fifth Street and Dunlap Avenue was destroyed by fire in 1975. This was one of Sunnyslope's most memorable fires and was fought by many other fire department units as well.

Pictured here is a typical Sunnyslope house, built in the 1930s on Second Way south of Dunlap Avenue. It was a wood-frame house built on pylon supports rather than a foundation. They were often made of surplus lumber or whatever the owner could find. Many had windows across from each other for cross ventilation, because most homes did not have air-conditioning, even in the hot Arizona summer months. During the summer, people often slept outdoors on cots with the cot legs in cans of kerosene to prevent bugs or scorpions crawling in the bed with them. Below is a similar Sunnyslope home; this one was built on Eva Street.

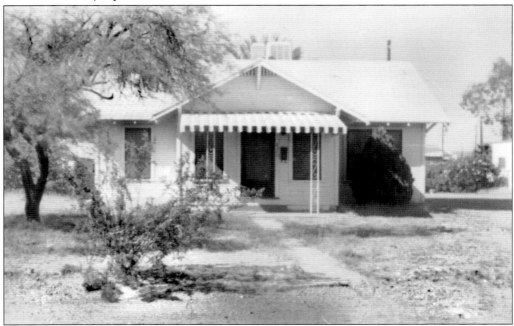

The comfortable home of Charley and Elenora Abels on Cave Creek Road was constructed by Charley at the height of the Cold War era, complete with a civil defense basement. Made of decorative cinder concrete blocks, the house had a flat roof, until the first monsoon came, causing Charley to quickly reconfigure it into a pitched roof. The Abelses were among the earliest Sunnyslope residents (see chapter 1). Charley was a disabled World War I veteran, but he and Elenora worked hard, pinched pennies, and he became an astute entrepreneur, serving his community as a state legislator for four terms. After they closed the store on Cave Creek Road and sold their Liquid Gold Water Company to the City of Phoenix, Charlie retired at age 62 "with enough money to provide his family with a good living for the rest of their lives," as he wrote in his autobiography.

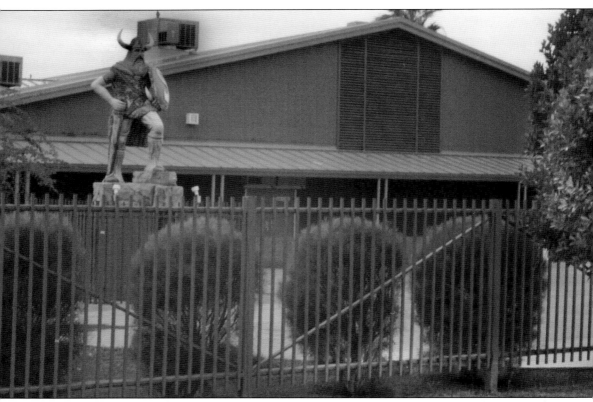

Sunnyslope High School, located on the north bank of the Arizona Canal, opened in September 1953 and graduated its first seniors in June 1954. The Viking shown here replaced a larger statue that had stood on the grounds for many years. In 1955, the student council decided that on November 8 each year, the annual painting of the S on the mountain would take place as an initiation for the freshman class.

Chancey Coors was the first principal of Sunnyslope High School. He served as principal of Sunnyslope High School for only a year and a half and was succeeded by Kenneth Coffin, his assistant principal, who remained in the position for 25 years.

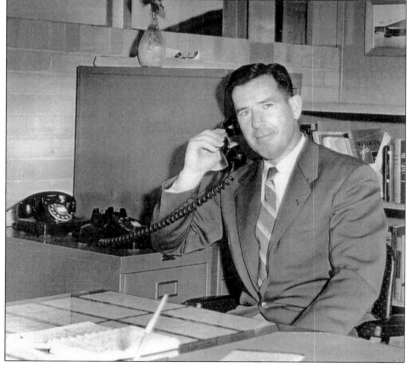

Kenneth Coffin was a dedicated school principal. Perhaps it was he who set the standard of excellence that continues to the present. Sunnyslope is considered one of the finest high schools in the state of Arizona.

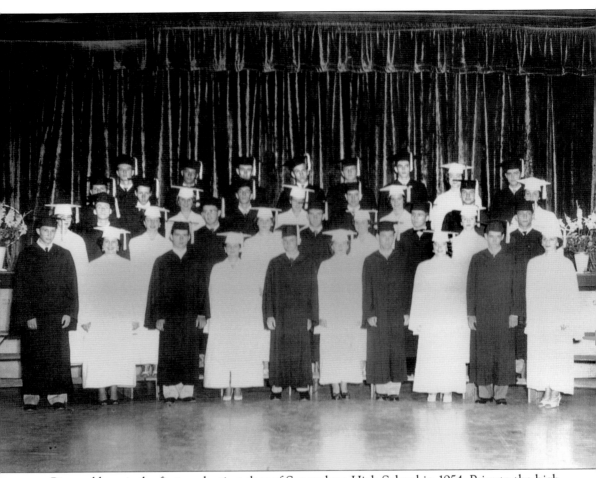

Pictured here is the first graduating class of Sunnyslope High School in 1954. Prior to the high school in Sunnyslope, high school students attended Glendale High School or Phoenix Union High School. When Sunnyslope High was built, some students attending Glendale chose to stay at Glendale, but these students chose to finish their last year at Sunnyslope.

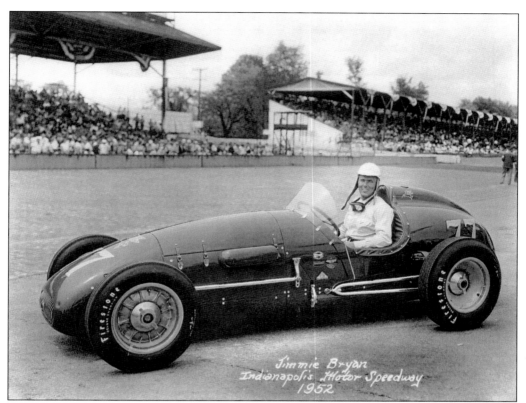

Jimmie Bryan
Indianapolis Motor Speedway
1952

Jimmy Bryan (January 28, 1926–June 19, 1960) is regarded by many as Arizona's greatest race car driver, a veteran of seven Indianapolis 500 races and a winner in 1958. Bryan grew up in Sunnyslope, just north of Hatcher Road on Fourth Avenue. His father, R.L. "Pete" Bryan, was assistant fire chief with Metro Fire Department at the Central Avenue Station. Jimmie reportedly built his first race car at age 13. It had a one-cylinder engine, a frame with wheelbarrow wheels, and no brakes.

Jimmy worked as an auto mechanic before racing full time. He would always wear one of three St. Christopher metals, as well as a penny or a dime in each shoe. Jimmy had the respect and admiration of his peers. A.J. Foyt said Jimmy was "one of the best dirt track racers I ever saw."

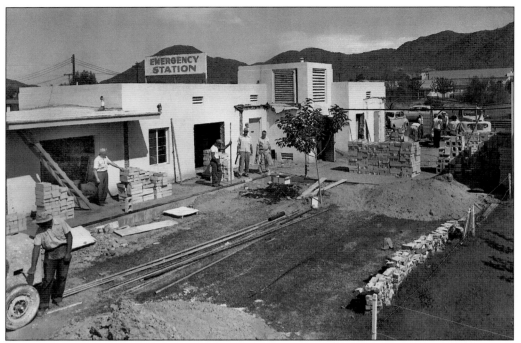

The John C. Lincoln Convalescent Home, the Roy Brooks Outpatient Clinic, and the Emergency Station were organized and licensed by Arizona Department of Health under the name Desert Mission Convalescent Hospital. Here, workers construct a new wing beside the Emergency Station.

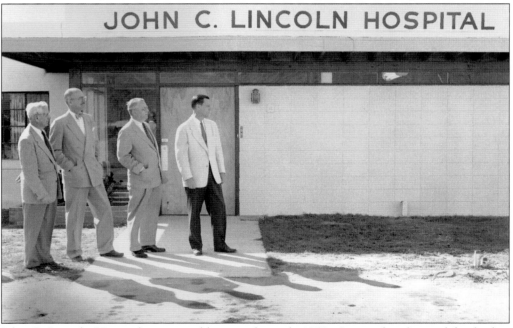

John C. Lincoln Hospital is pictured here in the early 1950s. Pictured in front of the facility from left to right are Ray Cowden, hospital board chairman; Dr. Bertram Snyder, chief of staff; and two unidentified men.

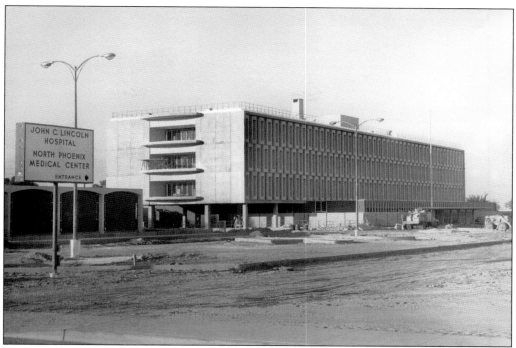

The multistory John C. Lincoln Hospital was built in the 1960s. The ground-breaking ceremony took place on May 23, 1963, with a dedication ceremony on January 10, 1965. When the Lincoln board of directors started discussing plans to establish a facility for various meetings, health care, a gym, and other functions on the Lincoln campus, the Cowdens were the first donate $500,000 for the project. Funds were raised, and the Cowden Center at 9202 North Second Street was built and dedicated on February 3, 1983, in honor of the couple who were major players at the Desert Mission and the John C. Lincoln Hospital.

Dignitaries at the ground-breaking ceremonies for construction of the multistory John C. Lincoln Hospital in 1953 included, from left to right, Gov. Paul Fannin, John C. Lincoln II, hospital board chairman Ray Cowden, Helen C. Lincoln, architect Ed Varney, and contractor Robert McKee.

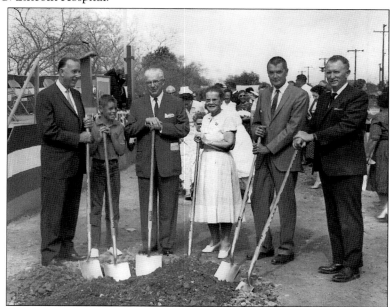

E. Ray Cowden came to the Salt River Valley at the age of 21 in 1912, joining his father and brother, who were already in Arizona. Ray and his brother, Claude, went into the cattle business under the name of Cowden Brothers, opening a cattle feed lot in the Lower Agua Fria Valley. Claude died in 1917. Ray continued and soon became known throughout the state's livestock businesses. By 1936, he operated huge ranches in the Tolleson and Seligman areas under the name Cowden Livestock Company. Cowden was introduced to Desert Mission in the 1940s, when asked by First Presbyterian Church to take charge of a sum of money earmarked for the mission and other facilities needed in the Sunnyslope area. Cowden was a good businessman with leadership ability; he and his wife, Ruth, were dedicated and enthusiastic supporters of Desert Mission and John C. Lincoln Hospital. Ray served on the board for more than 30 years, from 1949 to 1977. Ray and Ruth were the first to donate substantially when a meeting facility was planned for the John C. Lincoln campus—the result is known today as Cowden Center for Health Activities. It was dedicated on February 3, 1983. E. Ray Cowden died on August 25, 1986.

*Five*

# GROWTH OF BUSINESS

After World War II ended, real growth for Sunnyslope began. Subdivisions and middle-class housing, with brick and concrete block homes, replaced the tents and small cottages of the health seeker era. A new business area grew around Five-Points of Dunlap Avenue, Cave Creek Road, and Seventh Street. Sunland was one of the first new subdivisions, developed by realtor William P. Voita and Leslie Mahoney, a well-known Arizona architect. "Highly restricted," Sunland featured curved streets and more than 70 two and three-bedroom homes.

W.D. Upshaw, a local builder, followed with two tracts, North Central Heights and Upshaw Desert Heights. By the end of July 1947, Upshaw had almost 150 houses completed and another 60 ready for construction; he had the largest residential development in the state of Arizona at that time. Upshaw's efforts were "to give the buyers something really modern, with plenty of space." Upshaw homes helped make Sunnyslope a "solidly middle-class suburb." In addition to Desert Mission, Sunnyslope had three doctors and a dentist by July 1947.

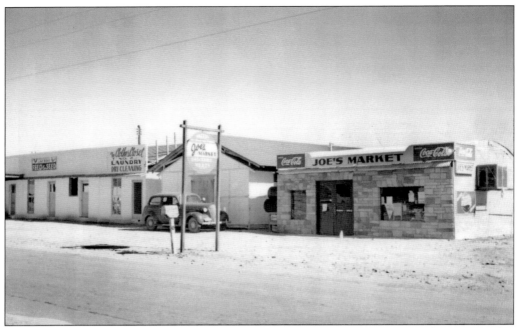

The earliest businesses were small and owner-operated. Shown here on the right, Joe's market was a Quonset-type building.

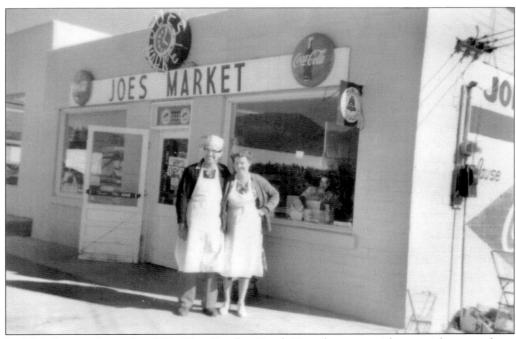

Joe's Market was located at 1111 West Hatcher Road. Here, he poses with an employee, perhaps Mrs. Joe.

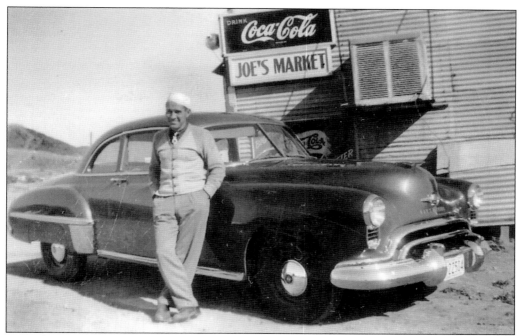

Mr. Salrin, who owned Joe's Market, poses with his nice new automobile. Note the competing Coca-Cola and Pepsi-Cola signs in the background.

Pictured here is the interior of Joe's Market. Notice the cartons of Pall Mall cigarettes, the display of sunglasses, and the 1950 calendar on the wall.

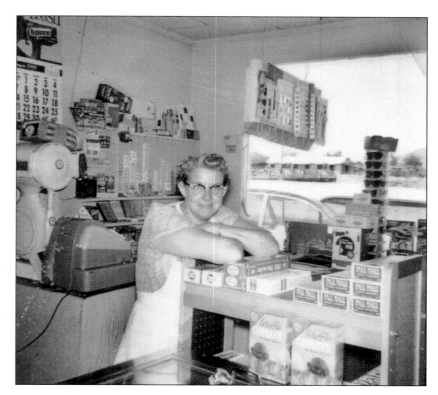

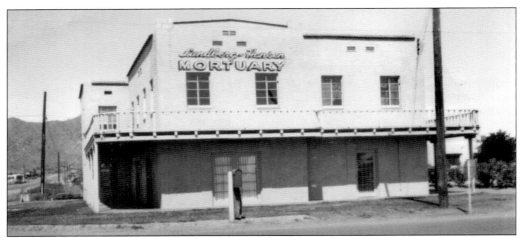

Lundberg-Hansen Mortuary, a pink stucco two-story building on the northeast corner of Central and Dunlap Avenues, was a forerunner of the widely known and respected business of today.

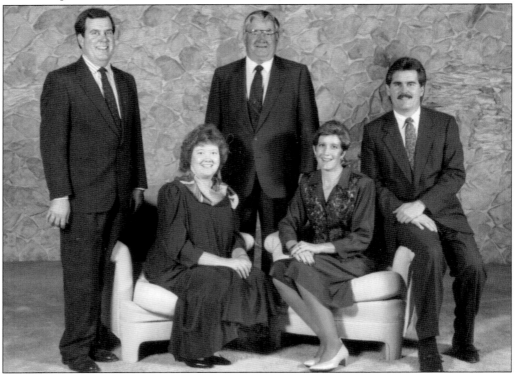

In 1950, Chester and Jan Hansen began their funeral business with the first Hansen Mortuary, located on Seventh Street just north of Northern Avenue. The second generation of the Hansen family expanded their father's business by purchasing Mercer Mortuary in Phoenix and Chapel of Prayer in Mesa. They built Desert Hills Mortuary and Memorial Park in Scottsdale. Continuing their parents' core values of "integrity for the deceased, care for the family, and charity to their community," the business is now over 60 years old and is operated by second-generation Hansens. Shown here with their father, from left to right are Brad Hansen, Rae Jeanne Repella, Trish Hansen-Kerr, and Craig Hansen.

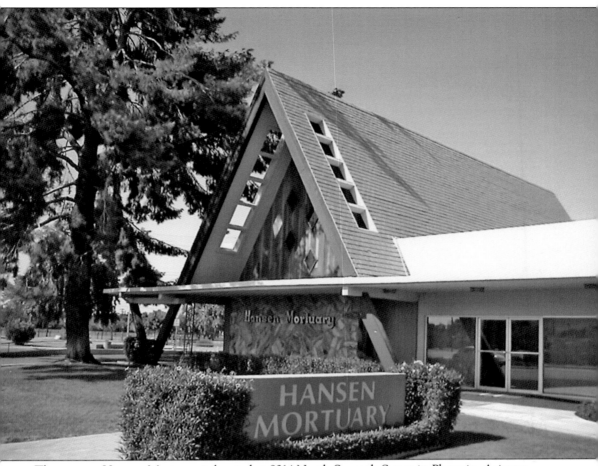

The current Hansen Mortuary is located at 8314 North Seventh Street in Phoenix, Arizona.

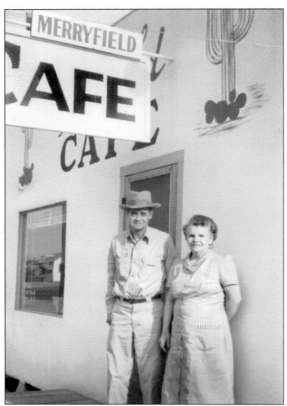

In this 1950s image, Roy and Lorine Merryfield stand by their café at 9145 Cave Creek Road.

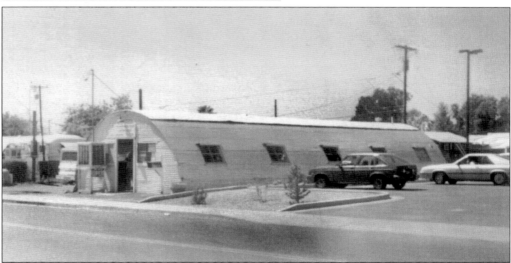

The Quonset is a World War II war-surplus building that was brought to Third Street in 1946 to serve as a Laundromat. It served as a home for many small businesses during the next two decades. From 1972 to 1995, it housed the small mom-and-pop business of Kreamer Wood Products. In 1972, Jim and Connie Kreamer moved in to the Quonset to continue their woodworking business when their home patio became too small. The Quonset served the Kreamers' business until 1995, when they retired.

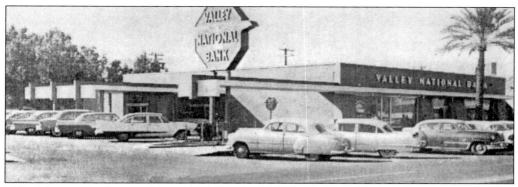

Valley National Bank is seen here in 1959. This bank was located at 501 East Dunlap Avenue. It served the community for four and a half decades. This bank became Chase Bank in the mid-1990s.

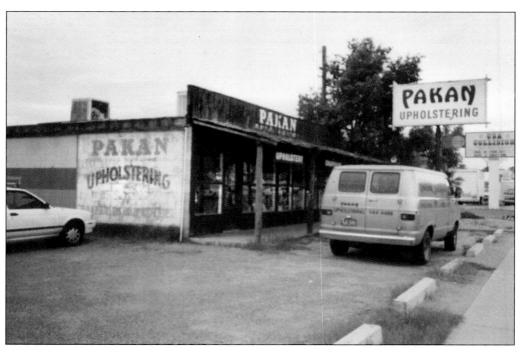

Pakan Upholstery, a family business, opened at 10016 North Cave Creek Road in 1954 and operated there for the next 60 years. Joseph and Crystal Pakan and their four children came from Chicago in 1945 because of Joseph's asthma, and built a home on two acres of land near Fourteenth Street and Cinnabar Avenue. Joseph's health improved, and in 1946, he opened an upholstery shop on Indian School Road where his 12-year-old son, Robert (known as Bob), began to learn the business. In 1954, the upholstery shop was moved to Sunnyslope. The Pakan sons, Joe and Bob, continued the business after their parents' deaths. The business closed in 2008.

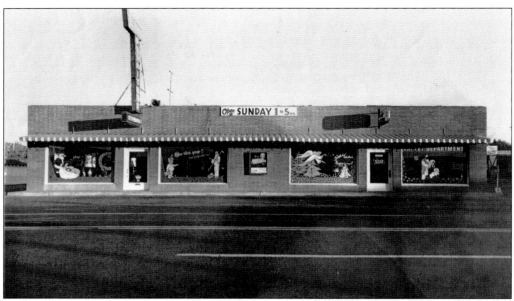

Sunny Furniture, at 500 East Dunlap Avenue, was the popular furniture store in Sunnyslope. It was owned and operated by Elsie Cummins, an active Sunnyslope businesswoman for four decades.

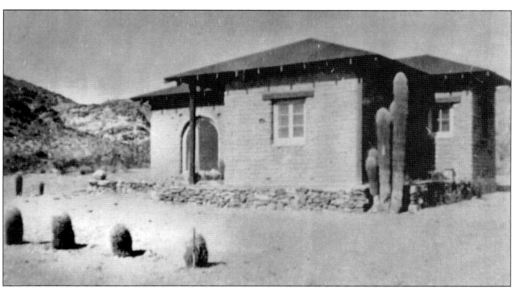

Here is Effie Barnes Sloan's home. Effie Barnes Sloan moved to Sunnyslope from Springfield, Missouri in 1919, with husband Claude Sloan, who had TB, and their three-year-old son, Claude Jr. They homesteaded 160 acres in the nearby desert. The homestead area lay west of Twelfth Street north of Palo Verde Street and east of Seventh Street north of Mountain View Road. It was a rugged, picturesque spot on a gentle slope, giving a view to the south. She volunteered at the Desert Mission after it opened in 1927. She worked for all three of the "H" directors (Hillhouse, Hood, and Hancox) and served on the Desert Mission board. In the 1950s, Effie sold and moved closer to the center of Phoenix. She died on February 9, 1990, just 19 days short of her 100th birthday.

The Watering Hole Bar and Restaurant was located in the area of Eighth and Tenth Streets and Peoria Avenue in a home that had belonged to one of Sunnyslope's earliest settlers, Effie Sloan Spires. Effie's first husband had tuberculosis, and they arrived from Missouri in 1919 to live on a desert homestead north and west of present-day Seventh Street and Mountain View Road.

Mac's Taxi Company was owned and operated by Edward Magilner, who lived in Sunnyslope for 25 years. He died in 1963 at the age of 56.

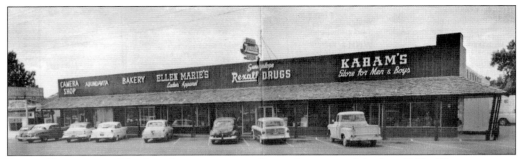

Pictured here is one of the first shopping areas in Sunnyslope around the late 1940s. The stores were varied and included Karam's Store for Men & Boys, a Rexall Drugs store, Ellen Marie's Ladies Apparel, a bakery, a camera shop, and a distributorship for Abundavita, a nutritional supplement.

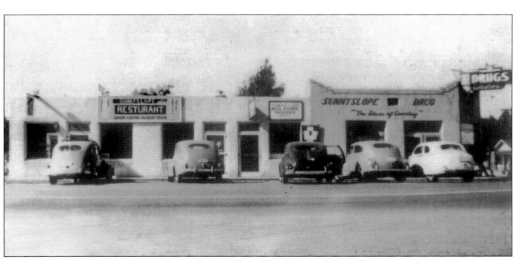

Sunnyslope Drug Store was on this southwest corner of Seventh Street and Dunlap Avenue, along with several other Sunnyslope businesses. Sunnyslope Drug Store was operated by Ralph Grando Jr. He served the community for 17 years. In 1962, he moved the business to 5351 North Sixteenth Street.

Lillian Stough, *Sage* newspaper editor, poses in front of her Sage Press building on the northeast corner of Cave Creek Road and Peoria Avenue. Bright, educated, opinionated, organized, and vivacious, this was a woman who knew her own mind. Four months before graduation from the University of Minnesota, Lillian accepted (with faculty approval) an unsolicited position in Washington, DC, as secretary to Minnesota congressman Ernest Lundeen. This began what she called "40 years of 'graduate courses' in the real world of political science." From 1933 to 1937, Lillian ran both the Washington and the Minneapolis offices for Representative Lundeen—researching, writing, studying and analyzing bills, organizing support for legislation, fundraising, campaigning, and representing her boss wherever needed. Concurrently, she served as executive secretary of the National Farmer-Labor Party, which was headquartered in downtown Washington. She and her first husband, Eugene Turner, came to Arizona in 1939, and in 1942, Lillian joined Gov. Sidney P. Osborn's staff. She became a special assistant and valued confidante to Governor Osborn, continuing into his second term; she outlined his speeches and often acted as his representative in public appearances. In 1943, Lillian, also managed a town hall–style radio forum series for KOY under the auspices of the USO. In 1943 and 1944, she helped organize labor committees around the state, especially among copper miners, helped with school desegregation campaigns, was an active member of the Democratic Party, and served as a delegate to the Democratic National Convention in Chicago in 1944.

## CHARLES S. STOUGH MEMORIAL SECTION

**SAGE**

Vol. 10, No. 24 - Jan. 14, 1965

## BRIEF TRIBUTES TO CHARLES S. STOUGH, SR. FROM A FEW OF HIS MANY FRIENDS

RICHARD F. HARLESS, former Member of Congress from Arizona, for whom Charley worked as Secretary in Washington, and also as Investigator in the County Attorney's Office. Long time friend...

"The passing of Charley Stough was a deep blow to many people. For a generation he had a strong influence over the lives of people in Phoenix and Arizona.

"When he became your friend, that friendship rang true, and he would spare nothing to help a friend. His devotion to country and cause was unsurpassed.

"Through the serious part of his life he always maintained a sense of humor. He had a deep understanding of people and gave generously of himself to help others. Not only his friends, but all who knew him will miss him."

DON DEDERA, writer... Arizona Republic columnist:

"We, especially those of us in the Newspaper fraternity, will continue to look for Charley Stough's dapper garb, his quick smile, his prankster's wit, his sympathy and loyalty toward good men and honorable institutions, and his faith in his corner of the state's capital --and I trust we will continue to find these trademarks of Charley Stough in his paper, THE SAGE."

CHARLES RONAN, former County Attorney:

... "He will be missed much by you, I know, and also this community. He was a real person in the fullest sense."

ALMA AND DICK GILBERT, Radio KYND:

"Charley Stough will be remembered by many for many different reasons but Alma and I shall remember him principally for his unfailing kyndness to us.

"His talents were so varied and distinctive that we are certain he gave entertainment, initiative, information, and inspiration with equal ease to those who were fortunate enough to know him, in person and through his varied and imaginative contributions to SAGE.

"Charley Stough was many things to many persons but to us he was a kynd friend-- and we miss him."

(Continued on next page)

"CHARLEY" AS HE SAW HIMSELF.. One of his favorite pictures.

His heart and mind, both overflowed
With kindliness--and mirth,
And every moment spent with him
Enhanced its fleeting worth...
Delighted chuckles, wisdom, repartee
Were Charlie's fare.
One just always "felt like going"
When he knew that HE'd be there!

The emptiness, the lonely hearts,
Created by his leaving,
Will be lightened, lifted, sent astray--
And banish times of grieving
When we know that in that Legion,
in the Greater Universe,
That Charlie has them all aglow--
With his stories, wit, and verse.

--Vi Farmer (Farmer's Gem Shop)

CHARLEY'S SLOGAN FOR SAGE..... **SAGE** THE ONLY NEWSPAPER YOU CAN OPEN UP IN A HIGH WIND OR READ ON A HORSE

This memorial section to Charles Stough appeared in the January 14, 1965, volume of the *Sage*. In 1945, Lillian joined disabled veteran Charles Stough as co-owner and editor-publisher of the *Sand*, a pro–Sidney P. Osborn political sheet that soon became a regular weekly newspaper, the first photo-offset newspaper in Arizona. The journalistic partnership and the *Sand* publication continued through 1950; in 1949, Lillian (now divorced from Eugene Turner) and Charlie Stough created a new partnership—they got married. Lillian never stopped her volunteer work or her political activities.

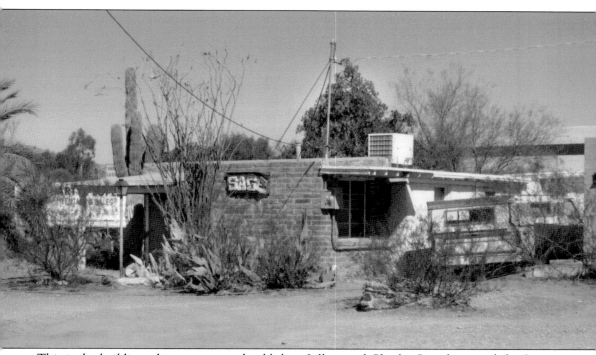

This is the building where owners and publishers Lillian and Charles Stough printed the *Sage* newspaper. It was a weekly publication of Sunnyslope, Cactus, and Paradise Valley community news. Lillian was involved in all areas of getting this newspaper out to the public. The Stoughs began a unique enterprise in 1955, when they established a magazine-size weekly newspaper, *Sage*, and a printing business known as Sage Press, located on Cave Creek Road about halfway between Dunlap Avenue and Cactus Road. The paper, touted as "the only paper you can open up in a high wind or read on a horse," served Sunnyslope, Cactus, and the growing community known as Paradise Valley. Until his death in 1964, Charlie was Lillian's loyal coworker, furnishing many of the ideas, drawings, and photographs, but Lillian was essentially the heart of *Sage*. Lillian continued the newspaper until she sold it to Jack Smyth, who also purchased the *Paradise Valley News* from Tom Morrow in 1970.

This *Sage* cover dates to November 15, 1956. It carries an article about the devastating fire that destroyed much of a local landmark, the old Arbor Café. Editor Lillian Stough writes, "The famous old 'Arbor,' 8525 North Central, is being 'improved' by its new owners. A modern night club is being planned. . . . They've bulldozed the beauty, Slaughtered the trees. I think that I shall never see Skeletons like these."

This *Sage* newspaper dates to March 8, 1956. Fires were a constant threat with small wooden homes and inadequate water supplies. As the newspaper notes, "A fire of unidentified origin completely destroyed the Dinger home, a frame structure located in the Hell's Canyon section of Cactus Saturday P.M." Happier news, however, was reflected with the cover photograph and story on page two about Sunnyslope's one and only Western rodeo.

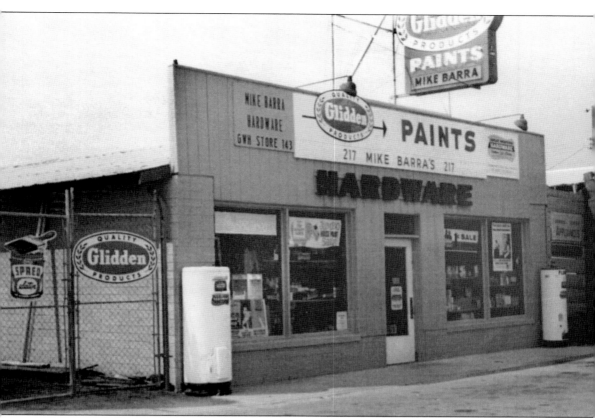

In 1947, Mike Barra opened his hardware store at 215 East Dunlap Avenue. Many Sunnyslope residents patronized this small store every day. It was the type of store where a person could buy one bolt or a handful of nails. Barra was a well-liked and civic-minded individual in Sunnyslope. He served on many committees to better the Sunnyslope community. Mike remained at this location until the mid-1980s, when the City of Phoenix deemed the building a blighted site and bought his property. Later, the Sunnyslope Village Plaza shopping center was built in the area. Mike Barra moved to Sunnyslope in 1939; he opened his Mike Barra True Value Hardware Store in 1947 and kept the store until he retired in 1985. He was a charter member and served a term as president of the Sunnyslope Lion's Club. He was an active member of the Church of Jesus Christ of Latter-day Saints. He was an oil painter and enjoyed classical music, trout fishing, and growing fruit. He passed away at the age of 90 on January 20, 1999.

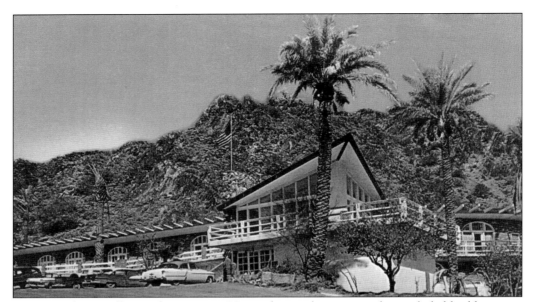

Dr. Kenneth E. Hall's North Mountain Hospital was a large, somewhat secluded building on a southwest-facing slope of the Shaw Butte–North Mountain Range. The legends that grew up around the good doctor and his medical practice matched the imposing facade of his edifice.

Northway Fish & Chips was a popular restaurant of the 1950s and 1960s in Sunnyslope.

Pix Theater was the first and only movie house in Sunnyslope with a grand opening, which occurred on November 20, 1947. It was located at East Dunlap Avenue and built in 1947. There was a 40-foot illuminated pylon, which was expected to become quite a landmark for the community. The exterior face was a split brick trim with a V-shaped marquee. The interior had a 27-inch frame around the screen, which was highly polished, giving a western motif to the inside. The foyer was covered with gold leaf wallpaper, and bright gold and red carpet was used on the floors and aisles to insure quietness. It had the latest in equipment, such as 672 airplane-type seats and louvered doors, instead of conventional drapes, for the inside entrance. It had the latest heating and cooling system, and it was equipped with Brinkert-Rc projection facilities. It was replaced by Mac Service Station.

Here is an ad in the *Sage* for the movie *The Jolson Story* at the Pix Theater. The theater's opening night featured Cornell Wilde and Maureen O'Hara in *The Home Stretch*. Vaughn Taylor was the manager. Today, the B&B Appliance is located in the Pix Theater building

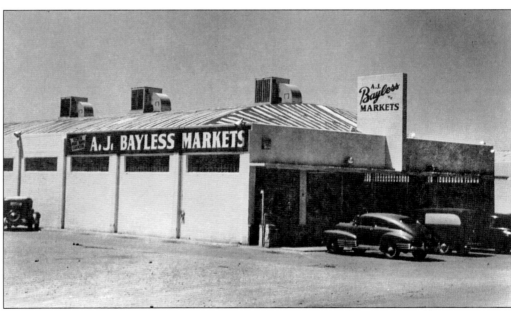

The A.J. Bayless Markets are shown here. In 1917, J.B. Bayless, a legendary food business owner, moved to Arizona, and in the ensuing years, he built a successful local chain of 18 stores, which he sold in 1929. His entrepreneurial mantle was picked up by his son A.J., who opened a grocery, A.J. Bayless Markets, "Your Home Town Grocer," on the south side of Dunlap Avenue.

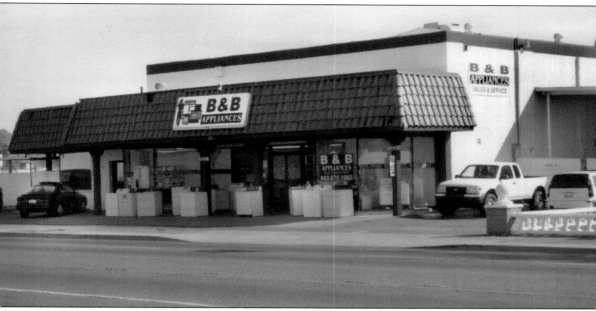

The present-day B&B Appliances, owned by Mike and Donna Bollig, continues to serve the Sunnyslope community in the old Pix Theater building at 331 East Dunlap Avenue. B&B Appliances is a well-known, family-owned business that has been in Sunnyslope since 1981. The 1947 Pix Theater building has been modernized with, according to B&B Appliances, a "contemporary redesign of the storefront façade, brick perimeter fencing, site repaving, roof enhancements, an upgraded fire suppression system, site lighting, landscaping and vertical signage—the last, a take on the original PIX Theater spire."

# SAGE

2ND CLASS MAIL PRIVILEGE      PHOENIX, ARIZ.

Vol. 14, No. 1 - February 15, 1968
P. O. Box 9157, Phoenix, Az. 85020

**13TH ANNIVERSARY**

By
Lillian Stough

Editor
Publisher
SAGE

(Since 1955)

AS THIS COLUMN IS STARTED there are stacked up on a table here 13 years of SAGE--waiting to be perused for historical material for this week's readers. In this 13th Anniversary Issue somewhere you will find a great deal of "way back when" photos and bits that once were news, for the entertainment and recollection of the area's "old timers" and, perhaps, to the surprise of some more recently arrived residents.

BUT AS OF NOW, this far in this column Your Editor has become bogged down in only the first two issues of SAGE, February 11 and February 25, 1955.

On page 1 of issue 1, it says: "CACTUS TO BLOOM". And it HAS bloomed--only there is no longer a "Cactus" town.

On page 1 of issue 2, it says: "ABELS OFFERS P.O. BILL. "Citizen Charley Abels was then a member of the State Legislature and he, like all the rest of us in "Cactus" town and Hell's Canyon and part of Sunnyslope, had a campaign going to save the Cactus Post Office. It was located where it had been for 20 years and more atop the hill in Cactus where a Chevron Service

(Continued on Page 7)

"THE TUCKERS".. Jeff Gilkinson (SAGE Reporter), left, and Doug Haywood, also of Sunnyslope, will be featured with Newport Folk Festival artist Sam Hinton in concert presented by Phoenix Folk Arts Society Feb. 28, 7:30, at Heard Museum, 22 E. Monte Vista. Advance tickets from Folk Arts Society, 2102 W. Flower, Phoenix 85015, $2. Also Lederman Music, Christown; Sandy's Records, 1906 E. Camelback.

**SAGE** THE ONLY NEWSPAPER YOU CAN OPEN UP IN A HIGH WIND OR READ ON A HORSE

Here is another article from the *Sage* of a historical nature, noting how much Sunnyslope had grown over the past 13 years.

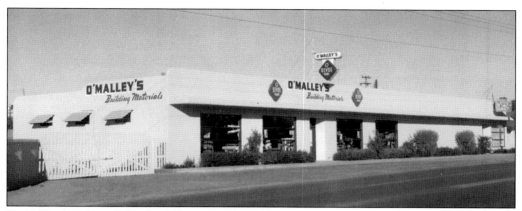

In 1947, after five of the O'Malleys completed their tours of duty in World War II, they were interesting in expanding their chain of lumberyards. They checked the Sunnyslope area and were astonished to find 8,000 people living north of the Arizona Canal. The company bought the property on northwest corner of Second Street and Dunlap Avenue to built an O'Malley Lumber yard. Ed Dunigan, the trouble-shooter for Ted O'Malley during the war, was an all-around good man to build this new yard. The building was large, and they were able to rent out the eastern part of it. After six years of business, they found that they needed to use the entire structure. By the 1970s, their business had grown, and they needed more room; however, zoning regulations would not allow expanding, so the company had to move out of the area.

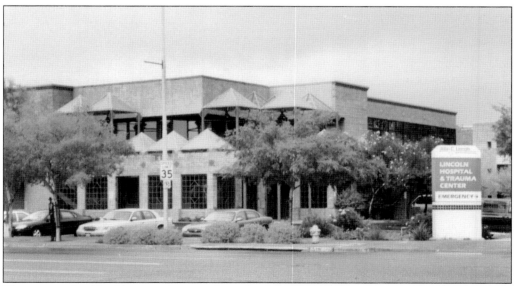

This is a medical building on the site where the O'Malley Lumber Co. was once located, today 50 East Dunlap Avenue.

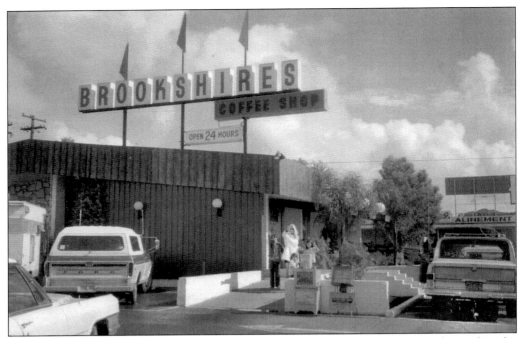

Brookshires Coffee Shop was a popular eatery for Sunnyslope residents. It was located at the northwest corner of Dunlap Avenue and Third Street. Jim Pencawski had the franchise for many years. It was located in the old Sunnyslope Plaza area. It was open seven days a week and 24 hours a day, making it a popular spot after hours. This building was constructed on the John C. Lincoln property. After the restaurant closed, the building was used by Lincoln for storage. It was demolished in 2008.

Fry's grocery store was first started in California by Donald Fry in 1954 and came to Arizona in 1960. Sunnyslope residents liked the convenience of purchasing food and prescription medicines with Fry's one-stop shopping. Fry's became part of the Kroger Company in 1980 but continues to play a role in Sunnyslope's community life today.

The September 13, 2000, dedication of the Sunnyslope Village Center was arranged by the City of Phoenix Neighborhood Services. Its director, Tammy Perkins, is shown at the podium. Seated from left to right are Sheila Gerry, senior vice president of John C. Lincoln Health Network; two unidentified people; former Phoenix mayor Phil Gordon; and city councilman Greg Stanton, who is the present-day mayor of Phoenix.

Sunnyslope Village is located on the southeast corner of Central and Dunlap Avenues. This shopping center was built on a vacant 12-acre site that was part of William R. Norton's 1911 subdivision that gave the area its name. The City of Phoenix applied the condemnation process to rid the blight many years prior to the shopping center's construction in 2000. Sunnyslope Village was a community effort by the City of Phoenix, City Neighborhood Services, Sunnyslope Revitalization, and A&C Developers.

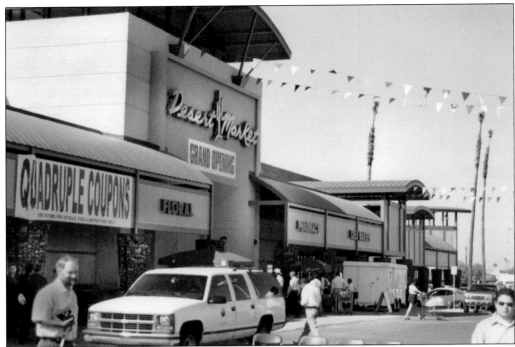

Food City, at 115 East Dunlap Avenue, is part of the Basha's grocery chain and caters to the Hispanic market by carrying a variety of foods and brand names that are not readily found elsewhere.

A crowd celebrates El Dia de los Muertos, "Day of the Dead," a traditional Hispanic holiday that honors the dead. The Oaxaca Mini Mercado (market) was located for a number of years on Central Avenue just north of Hatcher Road. Spanish-speaking families have always been a part of Sunnyslope, but large numbers of migrants began moving into the community in the 1990s, bringing new culture and customs with them and adding to Sunnyslope's heritage and diversity.

Preach Building and Landscaping is a family-owned business that operates from two locations: 1601 West Hatcher Road and 9430 North Sixteenth Avenue. Phil Preach and his family have been in Sunnyslope for many years, specializing in masonry building materials and landscaping supplies. Phil is the third child of Ed and Margaret Preach, who opened a masonry business in 1948 on North Twenty-fourth Street. After Ed's death and the loss of their property to new freeway construction, the Preach family moved the business to First Street and Dunlap Avenue in Sunnyslope, where they remained from 1968 to 1991. At that time, they relocated to 1601 West Hatcher Road, and later, they acquired an old adobe residence that has now been renovated for the landscaping service.

Pictured here is a traffic roundabout at Central Avenue and Mountain View Road. This "traffic-calming" structure was built in 2007 in response to some concern regarding area residents with speeding problems due to increased population at the top of Central Avenue and large apartment complexes being built.

*Six*

# SUNNYSLOPE HISTORICAL SOCIETY

Sunnyslope in the 21st century maintains an unique identity. The Sunnyslope Historical Society's goal is to preserve the heritage of this unusually dynamic, diverse, and multicultural community.

Connie Kreamer and Barbara Guiterrez's concern that local history would be lost caused them to organize and incorporate the Sunnyslope Historical Society in 1989. Volunteers began to give time, talent, and funds, a commendable practice that continues to the present, but there was no home for the organization.

In 1996, Sunnyslope Village Alliance invited the society to share office and meeting space in a Central Avenue building. Three years later, two historic buildings (the 1953 People's Drug Store and a 1945 residence) and a site at the corner of Eighth Street and Hatcher Road unexpectedly came to the society as gifts from A&C Developers and the Melluzzo family, respectively. The aging buildings were laboriously relocated, and a multiuse museum building was in place by 2003. Volunteer carpenter-craftsmen Jim Kreamer, Otis DeHart, and Hal Hall made the old brick drugstore safe, secure, and useful. A permanent exhibit featuring the original 1953 drive-through pharmacy window was installed in 2008, and in 2010, the Sage Press Exhibit opened to spotlight the Lillian Stough photograph and archival collection.

A large federal-city grant to stabilize and landscape the grounds was completed in May 2008. Dedicated, knowledgeable volunteers met regularly between 2006 and 2011 to research, plan, and gather artifacts for restoration of the 900 square-foot Lovinggood-Inskeep house, a potential candidate for National Register listing. In 2011, however, a series of mishaps changed the project from restoration to rehabilitation and a vital bit of history fell by the wayside. But the attractive, refurbished 1945 house opened on schedule in September 2012. The ribbon-cutting dedication ceremony was attended by a number of special guests.

Today, the landscaped Connie and Jim Kreamer Campus is made up of a research library and archives, a museum with permanent and changing exhibits, the 1945 house, and the Centennial Courtyard spotlighting the official state tree of Arizona, the palo verde. An all-volunteer board has oversight of society operations. And the beat goes on.

Sunnyslope Mountain, also called S Mountain, is not a tall peak in the foothills of the North Mountain, but it is an important one—the identifying icon of the community. Located near Central Avenue and Hatcher Road in Sunnyslope, the symmetrical landmark has been emblazoned for almost 60 years with a 150-foot-tall capital letter S. The emblem was constructed of painted rocks by Sunnyslope High School students in December 1954 and is whitewashed every fall by the incoming freshman class.

Here is the People's Drug Store building, future home of the historical society, at its original site, 111 East Dunlap Avenue. In 1953, Bob Rice built a new building that was state of the art—it had air-conditioning and the first drive-through pharmacy window in Arizona, one of only five in the nation. The drive-through window can be seen in this photograph near the front of the building on the right-hand side. The original window has been preserved in place. Inside the present-day museum, the window is a focal point of a permanent exhibit of People's Drug Store.

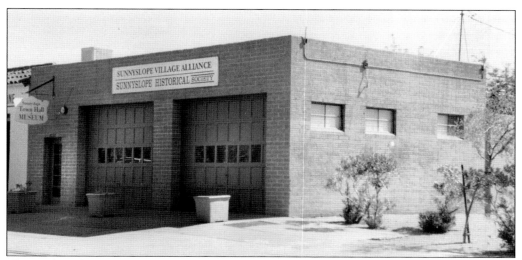

This readapted space at 8927 North Central Avenue was from 1993 to 2000 the home of Sunnyslope Village Alliance (SVA), a nonprofit that had formed to help Sunnyslope "become an ideal community for people to live, work, and play and a destination for all people in the Valley." In 1996, SVA invited the Sunnyslope Historical Society to share its office space. Affordable use for both volunteer organizations was permitted by the courtesy of the owner, Michael Nielsen. The brick building, a firehouse in the 1950s, housed Glenn Stouffer's carburetor garage.

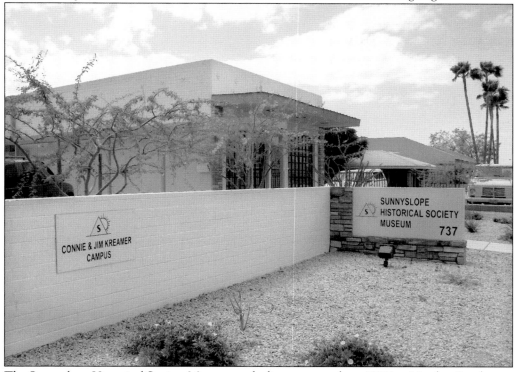

The Sunnyslope Historical Society Museum and adjacent grounds, at 737 East Hatcher Road, were renamed the Connie & Jim Kreamer Campus in January 2009 in recognition of their dedicated service to the society.

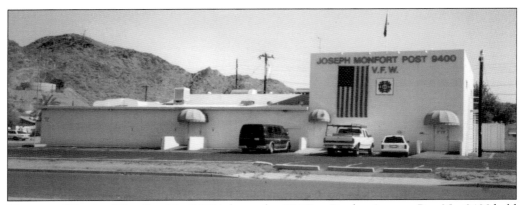

Veterans of Foreign Wars Post No. 9400 is located at 804 East Purdue Avenue. Post No. 9400 held its first meeting at the old Arbor Restaurant on Central Avenue south of the Arizona Canal on June 2, 1946, with 25 charter members. The first commander was William C. Vaughn, a veteran of both World War I and II. On Labor Day, 1948, the foundation for the VFW Montfort building on Purdue Avenue was poured by volunteer labor. The Montfort name was given to honor a World War II hero, Joseph F. Montfort, a Sunnyslope resident who had enlisted and then died as a prisoner of war in Formosa. Montfort Post formed a Ladies Auxiliary in 1948 with 14 charter members and Dorothy Bergstrom as president.

At an annual spaghetti fundraiser at the Italian-American Club, 7509 North Twelfth Street, the Sunnyslope Historical Society was honored with an appearance by the mayor of Phoenix, the Honorable Phil Gordon. Shown here are two Sunnyslope Historical Society board members, Connie Kreamer (founding president, left) and Bobbie Kraver (president at that time, right).

For a number of years, the Sunnyslope Historical Society participated with a booth or table at the annual Fall Festival, a community event held at Sunnyslope High School. Manning the table in the photograph is Jim Kreamer, who moved to the community with his wife, Connie, in the early 1950s.

Dave and Ruth Peterson, longtime residents of the community, were charter members of Sunnyslope Historical Society when it was formed in 1989. Ruth arrived in Sunny Slope in 1946 and, with her first husband, operated a small grocery store at Seventh Street and Dunlap Avenue. She and Dave were active members of the Sunnyslope Presbyterian Church and both served as elders. They enjoyed 27 years of marriage before she died in 2006; Dave passed away in 2012.

The Flores family moved to Sunnyslope more than 65 years ago and built a home at Fourteenth Place and Northern Avenue. All of the children graduated from Sunnyslope High School. Members of the extended Flores family are shown here at the January 19, 2013, annual membership meeting of the society. From left to right are Ralph Flores; Vivian and George Flores; Joe and Bonnie Flores; and their sister, Mary Flores Tesch, and her husband, Tom Tesch. George and Vivian's daughters, Stacey (standing) and Tracey (kneeling) are the two young adults.

Longtime residents of Sunnyslope often referred to themselves as " 'Slopers." The historical society sponsored a 'Sloper reunion that was called "Sunnyslope Community Day." Frank Melluzzo, a 'Sloper himself since 1935, when his family settled at Eighth Street and Cave Creek Road, would bring a yogurt machine and serve yogurt to the attendees.

Members of the historical society often gathered in the small office when the organization was housed at 8827 North Central Avenue with the Village Alliance between 1996 and 2000. Shown here from left to right are George Vest, Jim Kreamer, Connie Kreamer, Rosemary DeHart, Bernard Davis, Otis DeHart, and Dave Longey (seated in front).

A time capsule was placed in the wall of the museum in 2000 during a Community Day event. The cylinder is to be opened by members of the historical society in March 2020.

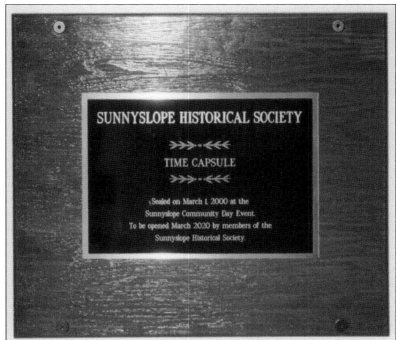

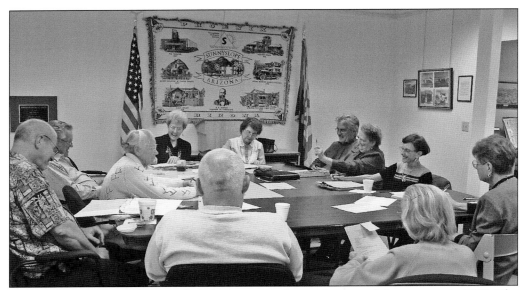

Pictured here is a typical society board meeting in the north room of the museum in 2005. The wall tapestry in the background depicts Sunnyslope history. Pictured, starting at the flag and moving right, are Reba Wells Grandrud, society president; Joyce Porter, secretary; Craig Hansen, Polly Martino, Bobbie Kraver, Connie Kreamer, Rosina Bria, Bob Rowe, John Jacquemart, Inona Coburn, and Ron Gawlitta.

This historic residence was moved to 737 East Hatcher Road as Sunnyslope Historical Society started a new life there. It was built in 1945 at 8924 North Second Street by Walter Leon Lovinggood for his family then sold in 1947 to Oliver D. and Corda Inskeep, who lived there, along with Norman and Florence Inskeep, until 1983. The building was acquired by Earl Getman as a business office for All Season's Electric. In 1999, after it was purchased by the City of Phoenix, it passed to A&C Developers, who donated it to the society. The SHS '40s House Committee spent more than 10 years planning and executing its rehabilitation and furnishing, and the house museum opened to the public in September 2012.

Continuing her tradition of documenting Sunnyslope history as it happens, Connie Kreamer photographed three members of the Frank Melluzzo family—Frank (right), daughter Kay, and son Wayne—at the annual membership meeting of the Sunnyslope Historical Society on January 19, 2013. Behind them on the museum wall is the Melluzzo Family Plaque and family portrait. Frank and his sister, Lu Melluzzo Perry, and their children gave the property at Eighth Street and Hatcher Road to the society in honor of their parents, Salvatore and Concetta Melluzzo, in 1999.

Started by Linda Rushton when she was on the society's board of directors, the society's home tour is a popular event in November. Jim Grose succeeded Rushton and is shown here with attendees and one of the shuttle vans used each fall, courtesy of American Valet, another great society supporter. Rushton and Grose have each served as president of the volunteer Sunnyslope Historical Society.

The Eye Opener Family Restaurant at 524 West Hatcher Road is a popular meeting place in Sunnyslope. The site and building have a long history beginning in the late 1950s, when it was Pedro's Mexican Restaurant, owned and operated by Frank and Robert Guglielmo. It became the Eat'n House in 1979 under Wayne and Priscilla Schlabach and Tom & Tiny's Family Restaurant from 1981 to 2003. Hal and Susan Mokbel became the new owners in 2003. The Mokbels have taken an active role in community life, and the restaurant is regularly used for community meetings. Shown here at the 2012 grand opening of the updated facility are, from left to right, Paul Harris (now retired) of Phoenix LISC (Local Initiatives Support Corporation); director Chris Hallett and Robin Anderson of the City of Phoenix Neighborhood Services Department; Hal and Susan Mokbel; Phoenix city councilman Bill Gates, District Three; and Joel McCabe, director of Desert Mission Neighborhood Renewal and Hatcher Road Committee chairman.

At the September 10, 2006, fall opening of the society, a tea honored "Members over Eighty." From left to right are (first row) Evelyn Childs, Inga Christoffersen, Trudie Baird, Sallie Dice Ide, Ellen Moffett, and Inona Coburn; (second row) Bill Hogan, Erigo "Fuzzy" Faust, Otis DeHart, George Vest, Alice Mabante, Tony Jones, and Polly Martino.

# BIBLIOGRAPHY

Abels, Charles H. *The Last of the Fighting Four.* New York: The Vantage Press, 1968.

*Building a Legacy: The Story of SRP.* Phoenix: Salt River Project, 2006.

Collins, William S. *The Emerging Metropolis: Phoenix, 1944–1973.* Phoenix: Arizona State Parks Board, 2005.

Ellis, Edna McEwen. *Sunny Slope: A History of the North Desert Area of Phoenix.* Phoenix: Art Press Printers, 1990.

Esch, Henry D. *The Mennonites in Arizona.* Phoenix: self-published, 1985.

Miller, Ruth. "A History of the Desert Mission." Typed manuscript submitted as part of Miller's graduate studies at the University of Arizona, Tucson, 1940.

Sheridan, Thomas E. *Arizona: A History.* Tucson: University of Arizona Press, 1995.

# DISCOVER THOUSANDS OF LOCAL HISTORY BOOKS FEATURING MILLIONS OF VINTAGE IMAGES

Arcadia Publishing, the leading local history publisher in the United States, is committed to making history accessible and meaningful through publishing books that celebrate and preserve the heritage of America's people and places.

## Find more books like this at
## www.arcadiapublishing.com

Search for your hometown history, your old stomping grounds, and even your favorite sports team.